CONTESTATIONS LEARNING
 FROM CRITICAL
 EXPERIMENTS
 IN EDUCATION

TIM IVISON &
TOM VANDEPUTTE
(EDS.)

CONTRIBUTIONS BY:
FRANCO BERARDI
SEAN DOCKRAY
JAKOB JAKOBSEN
NILS NORMAN
GREGORY SHOLETTE
ULTRA-RED

C

S

S

CONTESTATIONS

LEARNING FROM CRITICAL EXPERIMENTS IN EDUCATION

Edited by
Tim Ivison & Tom Vandeputte

Bedford Press London

CONTENTS

25 Tim Ivison & Tom Vandeputte
 CONTESTATIONS

31 Franco 'Bifo' Berardi interviewed
 by Tim Ivison & Tom Vandeputte
 AUTONOMY AND
 GENERAL INTELLECT

43 Gregory Sholette
 THE ACADEMY
 FROM BELOW?

63 Sean Dockray
 OPENINGS AND CLOSINGS

83 Pablo Garcia, Janna Graham
 and Leonardo Vilchis of Ultra-red
 WHAT IS THE SOUND
 OF RADICAL EDUCATION?

113 Nils Norman
 UNWRITING EDUCATION:
 ON THE SCHOOL OF WALLS
 AND SPACE

129 Jakob Jakobsen
THE PEDAGOGY OF NEGATING THE INSTITUTION: REFLECTIONS ON THE ANTI-HOSPITAL AND THE ANTIUNIVERSITY

153 Biographies

156 Colophon

157 Acknowledgements

159 Appendix

If access has moved from a question of rights (who has access?) to a matter of legality and economics (what are the terms and price for access, for a particular

person?), then over the past few decades we have witnessed access being turned inside-out, in a manner reminiscent of Marx's 'double freedom' of the proletariat, in which

we have access to academic resources but are unable to access each other

Sean Dockray

Tim Ivison & Tom Vandeputte

CONTESTATIONS

There has been a distinct renewal of critical interest in education, both as a field of experimentation and as a mode of political and social organisation. Artists, activists, theorists and educators have become involved in a broad range of alternative practices, varying from informal reading groups and seminars to self-organised schools, community-based pedagogical experiments, and online learning platforms. Many of these projects are based on a distinct premise: that the process and space of learning can be a political experiment in and of itself. The heterogeneous forms of organisation and engagement they employ are seen as a way of cultivating discourse and community, raising consciousness, formulating new problems and finding new strategies of response.

These alternative and experimental approaches have come into focus at a moment when the traditional academic system finds itself under enormous pressure.

We have witnessed a marked intensification of the neoliberalisation of education, a process that has been underway for at least the last two decades. In many parts of the world, the implementation of austerity policies in the wake of the 2008 financial crisis has resulted in a sustained attack on education, putting at risk the funding and spatial resources of academic institutions, as well as their educational objectives. The purpose of the university is increasingly understood in terms of attendance numbers, evaluation procedures and efficiency regulation; institutions are forced to restructure, commodify, privatise and close down departments that do not conform or compete. Supported by national and international policy agreements, local and state governments, police and private security forces, these measures are not simply an inevitable effect of economic contraction, but rather a deliberate and sustained political intervention in the sphere of higher education. A market logic is now instilled across all fields of teaching and research, throwing the relative autonomy of the university into question.

Although recent experiments in education emerge from many specific motivations, the higher education crisis has given them new and broader political relevance. Self-organised schools and alternative learning platforms can be understood both as critical responses to the academic establishment and as speculative attempts to develop viable alternative spaces and models of learning. As mainstream institutions continue to raise tuitions and privatise campuses, prospective students are turning to short courses, night schools, free schools and self-organised learning spaces in the margins. Additionally, ad hoc educational initiatives have recently appeared as an integral part of protest movements in both Europe and the Americas, where the topic of education has been a specific flashpoint.

This book brings together a number of critical reflections on education as a form of political engagement. Our aim is to identify the key questions and problems posed by educational experiments and draw out new concepts and strategies developed in response to the present crisis. Through this collection of essays, interviews, and conver-

sations, we seek to underline a common project that all of these practices, to a greater or lesser extent, seem to share: the contestation of the current direction of academic institutions, and the attempt to rethink the structures and spaces of learning on a fundamental level.

The essays gathered here take up positions along a spectrum of engagement. While some contributors work from within mainstream institutions of learning and attempt to carve alternative paths for educators and students, others have abandoned or exiled themselves from such structures to pursue alternatives. Together, these texts address a variety of organisational and pedagogical concerns, ranging from programme curricula to institutional economies; from the student-teacher division, to models of collective learning. Rather than functioning as a comprehensive survey of critical education, this book presents a cross-section of the discourse by offering different starting points for further discussion and experimentation.

Contestations appears in the context of a trenchant discourse on the education

crisis and its political economy, as well as proliferating discussions on arts education, the engagement of artists with education, and strategies of self-organisation. We share many of the questions and concerns that have emerged from these discussions: the desire to experiment with new institutions and learning communities; the struggle against technocratic neoliberal management and funding; the increasing externalisation of the basic provisions of education into cultural sectors ill-equipped to fill in the gaps; and perhaps even the specific problems that this situation might pose for art and design education.

While the current discourse is often argued from the standpoint of university programmes, museums and non-profit institutions (that is to say, from the vantage point of the administrators of culture and education), this book focuses on the practices situated in the cracks of these institutions, and what lies beyond their walls. It seems that this shift in attention from institution to practice can reveal a more fundamental rethinking of the forms and structures of education: one that could start from the

experience of learners and teachers, while engaging in a search for new goals and criteria that may or may not lead back to existing models. Once marginal and tactical, the discourses and practices discussed here increasingly represent practical, even necessary steps towards post-neoliberal learning.

 London, April 2013

Franco 'Bifo' Berardi interviewed
by Tim Ivison & Tom Vandeputte

AUTONOMY AND GENERAL INTELLECT

TI / TV – The ongoing crisis in higher education has recently intensified as a result of widespread government austerity measures. In order to effectively respond to the crisis, it seems imperative to have an adequate description of its functioning in practical and theoretical terms. In that sense, what is your analysis of the situation of higher education today?

FB – During the past decade, the European ruling class launched an overall attack against the principles of mass education. This attack, whose primary target is the privatisation of the school and of the university, is the assertion of neoliberal ideology in the field of knowledge, research and information. This implies the primacy of the economic paradigm of profit and competition in science and education, and therefore the cancellation of the autonomy

of knowledge as the essential feature of the modern institution of the university. Autonomy does not only mean the political independence of the university as an institution, but also and mainly, the epistemological principle of the freedom of research.

In a way, the crisis of the university was already embedded in the inability of modern humanism to cope with the acceleration and complexity of the infosphere. The university of the past, as we have inherited it from modernity, is unable to deal with networked intelligence. Yet the crisis of the university is precipitating because the financial dictatorship is destroying every space of autonomy for intellectual life. The context nowadays is marked by the financial attack on the mass education system, the dismantlement of the general intellect, the definancing of the public school, the barbarisation of society. The educational system is under aggression because the financial dictatorship is plundering the resources of society and destroying the very foundations of modern civilisation.

All of this can happen because the financial class has no interest in the future.

The old bourgeoisie was interested in the future of the territory and the urban community because they could only sell goods produced in factories and therefore reproduce their wealth thanks to the prosperity of the territory. The old industrial bourgeoisie was a strongly territorialised class – it was the class of the *bourg*, of the city. Financial accumulation, on the contrary, is not based on selling useful goods to the community or on the prosperity of the territory. It is based on the game of buying and selling financial products whose usefulness is nothing.
In the bourgeois industrial economy, money was used as a tool for the production of goods, and the production of goods was the necessary step for the accumulation of money (money–goods–money).

Financialisation has changed the process: money is producing money without any production of useful things – physical and semiotic. Financial products are just simulations that trigger the accumulation of more simulation, and this simulation is devastating the world, as we see with the present European crisis. The process of privatisation has totally destroyed the

autonomy of the university and its ability to produce knowledge. There is no knowledge without epistemological autonomy, and there is no epistemological autonomy when capitalist dogma is submitting knowledge to the obsession of profit and competition and growth. Now more than ever we have to invest our political and cultural energy into the creation of an autonomous process of self-education, of research and transmission of knowledge.

TI / TV – You have written extensively on cognitive labour and mass education in relation to political struggles. How do these concepts inform your understanding of the historical basis for contemporary education struggles?

FB – Mass scholarisation is the meeting point of two historical processes: the worker's push for emancipation and the technological transformation of capitalist production, which is possible thanks to the application of cognitive labour. During the twentieth century, the conflict between workers and capital took the form of a

continuous push towards redistribution of wealth – the increase of wages – but also, and mainly, it was a push towards the emancipation from industrial slavery, which took the immediate form of reduction of labour time. Capitalism responded to this pressure by introducing machines – concrete manifestations of the scientific and technological application of the 'general intellect'.

Marx speaks of general intellect in the *Grundrisse*, particularly in the 'Fragment on Machines'. This expression refers to the productive potency of science and technology, which is the effect of the cooperation of intellectual workers. In the 1960s, Italian compositionist thought, usually known as *operaismo*, developed a conception based on this premise: that the productive force of science and technology can replace the physical activity of industrial workers. Thanks to the application of intellectual potency, capital can increase productivity and develop innovation and new products. At the same time, physical fatigue is replaced by machines. In this way, replacing industrial work by intellectual activity is a common interest of capitalists and workers.

In the second part of the century, mass scholarisation opened a possibility of emancipation for the working class: the worker's 'refusal of work' entered into contact with the 'general intellect'. The student movements of 1968 can be seen as the first insurrection of the general intellect: the solidarity between students and workers was not only an ideological effect but also the alliance of two social subjects that shared the same interests. First, students were the harbingers of the intellectual potency. They were able to increase productivity and use technology to emancipate human beings from the slavery of physical labour. And workers, conscious of the obsolescence of the industrial mode of production, were pushing towards the reduction of labour time. This alliance marked the emergence of the technological replacement of industrial labour with the info-machine and opened the way to a large process of emancipation, and of transformation. The digital revolution can be seen as the final point of this historical movement: engineers, researchers, technicians and info-workers created the possibility

of emancipation of human time from the slavery of industrial work. Unfortunately the slavery of networked work was coming, as the capitalist form had not been dismantled.

This process of emancipation was perverted and disrupted by neoliberal philosophy in the last decades of the past century. The neoliberal revolution (or counter-revolution to be precise) twisted the force of the general intellect against the workers' autonomy. Technology that had offered the possibility of emancipation became a tool for control. The increase in productivity, which potentially opened the way to a general reduction of labour time, was turned into a tool for increased exploitation, while the limitations on work times were removed, and unemployment rose as an effect of the increased work time of the individual. The potential of the general intellect has therefore been fully exploited by capital, but this exploitation has happened against the social interest.

As cognitive labour was, in those years, becoming the main force of valorisation, capital attacked the movements and tried to subject them to an ideology of merit,

or meritocracy, and struck the social solidarity of the intellectual force. Meritocracy is the Trojan horse of neoliberal ideology; it identifies intellectual ability with economic reward. Meritocracy is not actually based on intellectual or technical skills, but on competition between individuals in a prospect of aggressive self-affirmation. Precariousness is the hotbed of meritocracy. When individuals are obliged to fight for survival, intellectual or technical ability is reduced to a tool for economic confrontation. When solidarity is broken and competition becomes the rule, research and discovery are disconnected from pleasure and solidarity, they are reduced to instruments for economic competition. The student movements from 1968–77 therefore mark the emerging consciousness of the material interests of the intellectual force. At the same time they demonstrate the need for a process of autonomisation in learning and research.

TI / TV – In your work you have emphasised the importance of the free radios and other forms of media activism in the movements of the late 1960s and 70s. What do you

consider to be their particular force or effectiveness? In our own research we have taken a particular interest in critical experiments in education as a form of creative resistance, but here we might turn it around and instead ask: to what extent can media activism be understood as a form of self-education in its own right?

FB – Media activism has been and is the first space of self-organisation of cognitive labour. The experience of free radios in the 70s is an early example of how protest and refusal of capitalist rule can turn into the self-organisation of cognitarian workers (ie, technicians, journalists) and the creation of an autonomous sphere of communication. I use the word 'cognitarian' in order to refer to these precarious cognitive workers; I see the cognitive side of the productive activity of the mental workers, but also the proletarian side that is hidden, forgotten, denied by the ideological description of the networked economy. They are the avant-garde of the cognitarian emancipation to come. Throughout the past decades, thousands and thousands of journalists, writers, artists,

technicians and programmers who have been marginalised by the corporate system of the mediascape have opted for self-organisation and have created an autonomous sphere of information, subversion and self-formation.

The free radio movement has been an experiment in technological self-education and the creation of a horizontal network of information. In the Italian experience for instance, the interconnection of the telephone and the radio broadcast was crucial during the 1970s. The telephone gave people the possibility of intervening in the radio's flow of information. As far as the Italian mediascape was concerned, this was absolutely new. The political innovation of the free radio movement was essentially based on this: the radio is the voice of people who have never had the opportunity to speak. From this point of view the philosophy of the internet was already at work in the free radio movement of the 1970s.

TI / TV – Earlier in this conversation you argued for the need to invest in autonomous processes of self-education. Where would

you locate the struggles in education: inside or outside of the university?

FB – Both inside and outside. Outside of the university, we have to create concepts for the new institutions of research and transmission of knowledge. SCEPSI (European School of Social Imagination), which we launched in San Marino and Barcelona in 2011, is an attempt to create the concept of an institution based on the political and epistemological autonomy of knowledge. From time to time, a group of researchers, philosophers, scientists and activists meet publicly, thanks to the availability of existing institutions (museums, academies, universities) that lend their spaces and resources for the organisation of nomadic lectures, which develop the common programme of a sceptical form of interdisciplinary research. As a concept, SCEPSI is an experiment in exemplifying the possible functioning of an institution based on this autonomy in the age of the networked general intellect. While the neoliberal restructuring of the university is based on the separation of the humanities from the scientific branches

of knowledge, SCEPSI aims to find interdisciplinary answers to interdisciplinary questions. While the neoliberal form of the university and the school is based on the dogmatic idea that knowledge must be rentable in economic terms, merit equals competition, and profit is the goal of research and of innovation, SCEPSI refuses any dogma – any truth, any preconceived order of priorities. While the neoliberal university and school uses the internet as a tool for implementing the economic profitability of knowledge, we try to conceive of the internet as an environment of life, affection and knowledge, not as an instrument.

On the other hand, we have to act inside the decaying institution of the university. We have to go into the corpse of what used to be the living organism of the educational system in order to mobilise and autonomise as many cognitarians as we can. We need to organise the exodus of poets, engineers, artists and scientists – a self-organisation of knowledge inside the very place of intellectual subjection.

Gregory Sholette

THE ACADEMY FROM BELOW?

The Cartographers Guilds struck a Map of the Empire whose size was that of the Empire, and which coincided point for point with it.[1] – Jorge Luis Borges

Pedagogical activism is the latest tactical mutation of cultural resistance to the society of risk and its neoliberal enterprise culture. It takes numerous forms including well-grounded organisational structures to be sure, but this is becoming increasingly atypical. Instead, most of these educational interventionists begin as ill-defined bands or gatherings and only arrive at a degree of stability as if by accident. Often this involves clever acts of artistic mimicry, which permit these informal organisations to bring about a seemingly full-blown institutional reality while skipping right past customary procedures and formulae such as filing legal papers, choosing a board of directors and publishing annual reports. These informal art and research models reflect an increas-

ingly widespread phenomenon in which artists and informal collectives combine their desire to reimagine or literally reinvent organisational structures with an interest in DIY pedagogies and autodidactic forms of instruction. Some participants apparently find their own presumably sophisticated education suddenly lacking and seek to create new, self-designed art programmes. Others openly reject what in the United Kingdom is referred to by neoliberal policy wonks as 'enterprise teaching' or 'entrepreneurial learning', or in the United States as the very theft of life itself through a pedagogical system-turned-graveyard. For example, a grim 2009 communiqué from the student-occupied campus of the University of California at Berkeley reads in part:

Incongruous architecture, the ghosts of vanished ideals, the vista of a dead future: these are the remains of the university… like the society to which it has played the faithful servant, the university is bankrupt. This bankruptcy is not only financial. It is the index of a more fundamental insolvency,

one both political and economic, which has been a long time in the making.'[2]

University students are demanding to be liberated from the 'cemetery' of higher education. In fact, they are attempting to escape the 'graveyard' of liberal good intentions, as learned institutions fail to live up even to their own promises of assuring meritocracy, opportunity, equality and democracy, and turn into neoliberal edufactories instead. The various manifestos and communiqués from 'an absent future' signed by 'occupied Berkeley', alongside the May 2010 student takeover of the Middlesex University campus buildings in reaction to the elimination of the school's renowned philosophy department (a choice based on financial grounds) reflect not only the grim state of education in the twenty-first century, but also its potential rebirth.

For two months in late 2009, Austrian students occupied the University of Vienna, calling for the abolition of tuition fees, improved working conditions for faculty and staff and greater democracy throughout the nation's educational system. They were

evicted. However in the early hours of 22 December, the students began organising new protests in front of the university using digital networks to coordinate flash mobs; large groups of people suddenly converged and dispersed at set times and in particular public spaces, based on arrangements through email, Twitter or cellular text messages – a technique Iranian demonstrators used to mobilise their opposition to the government of Mahmoud Ahmadinejad. Several months earlier, students at The New School in New York City occupied the privately owned university cafeteria for the second time in a year. Barricaded inside, they demanded the resignation of New School President Bob Kerrey, a strong advocate of the Iraq war and neoliberal education reform. Police violently uprooted the protest using caustic pepper spray (perhaps an ominous precursor to the viral image of the UC Davis security guards who sprayed protestors of the Occupy movement on 18 November, 2011). Yet the standoff of students, along with the support of the faculty union and school administrators, appears to have influenced Kerrey's

decision to not seek a new contract at the end of his term in 2011 (although he received an alleged $1.2 million bonus after his resignation). Across the country, similarly dramatic occupations and protests swept through the University of California school system, which administered deep budget cuts and other cost-reduction measures in the wake of the 2008 financial collapse.

It seems that those who labour in or are being 'processed' by the neoliberal edufactory system have begun to revolt, and the new structural adjustment initiated by the so-called Great Recession has served as a focusing agent for this rebellion. What's more, theories of tactical urbanism, cultural intervention and institutional impersonation go hand-in-hand with this new campus insurgency: here, artists (neoliberalism's favourite knowledge proletariat) play a key research and development role. Clearly, the actions of Occupy Wall Street are an outgrowth of this conversion. One particularly active spinoff group from New York's General Assembly has called for the complete erasure of student debt through a collective pledge of refusal, even as its

members task society with reimagining the 'semiotics' of labour and wages in a post-industrial era:

The struggle over wages was a defining feature of the industrial era. We believe that the struggle over debt will play a similar role in our own times. Not because wage-conflict is over (it never will be), but because debts, for most people, are the wages of the future. [3]

Artists remain central figures in these recent attempts at reconfiguring education against the market and within a resuscitated notion of the commons. In Los Angeles, a group of artists have established their own teaching platform called The Public School. The project, developed by several artists, consists of an online programme that allows participants to design classes they want to take but cannot find elsewhere – from practical technology-related workshops, to theoretical seminars. Once enough students register for a particular course, an appropriate tutor is hired to instruct, and a modest fee is charged for each seminar.

Currently, there is no existing municipal or government support for this educational project whose name is simultaneously a straightforward reference to the scheme's open, democratic structure as well as a play on words that calls the bluff of the failed California public school system. And since its founding, clones of The Public School have emerged in New York City, Chicago, Philadelphia, Brussels, Paris and San Juan.[4] For instance, in Brooklyn, a new art academy called The Bruce High Quality Foundation (BHQF), mixes economic fears spurred by the financial meltdown with efforts to critically reimagine art education. Yet, BHQF is not a foundation anymore than there is anyone named Bruce High Quality. With support from the public art foundation Creative Time, the faux foundation of BHQF recently launched the Bruce High Quality Foundation University (BHQFU),[5] whose online mission statement – a possible allusion to the French Invisible Committee manifesto *The Coming Insurrection* – begins with the stormy words, 'Something's got to give. The $200,000-debt-model of art education [in the US] is simply untenable…

[and] mired in irrelevance.'[6] That 'irrelevant' quagmire is further described as 'blind romanticism and a blind professionalism' – an academic zeitgeist that BHQFU insists has been waging a false battle for the hearts and minds of contemporary art students.[7]

These days, the impending insurrection is everywhere. On 9 March 2008, Russian authorities closed the European University in St Petersburg, allegedly due to fire code violations. One month later, unemployed university members organised the first of an ongoing series of impromptu classes held on a pedestrian street in the centre of the city. The Street University included students, as well as members of the Russian artists' collective Chto Delat/What is to be Done?,[8] and offered classes in student activism, consciousness-raising and lectures on the Situationist International. Other programmes featured rare open debates of radical political theories. After the organisation of a second spontaneous street classroom, the European University officially reopened. Nonetheless, Street University (SU) continues to meet, even though its members admit 'reorganisation during

"peacetime" is difficult.'[9] Still, as Chto Delat loudly proclaims, 'The task of the intellectual and the artist is to engage in a thoroughgoing unmasking of the myth that there are no alternatives to the global capitalist system.'[10]

One informally structured programme, located in Manhattan's financial district for more than a decade, may represent a rudimentary template for sustaining this new and radical pedagogy from below. 16 Beaver Street (16 B) is both the address and moniker of a reading group in which participants meet weekly to discuss texts, listen to visiting scholars and artists, and watch videos related to topics of interest generated by group members. There are no restrictions on who can participate; anyone who shows up and steps off the elevator into the loft may join in the discussion.[11] Despite more than a decade of programming, the group has never metamorphosed into a legal entity – commercial, not-for-profit or other.[12] Funding for events and for the loft itself has largely been accomplished by subletting part of the space to a commercial artist. It is further sustained by untold hours of in-kind labour provided by members and supporters.

However 16 B's uncluttered, stripped-down organisational model is deceptive. The highly sophisticated intellectual and pedagogical learning that this anomalous non-organisation supports ranges from topics such as Palestinian culture and resistance to the war in Iraq, to debates about economic neoliberalisation, the increasing private concentration of media, art and politics, and the 'joys and poetics of resistance to capitalist alienation'.[13] Like the group's spare organisational structure, its meeting space is uncluttered and plain – almost a tabula rasa awaiting inscription. Other than a few dented track lights, several randomly placed metal eyehooks and a corridor leading back to a small kitchen, little occupies the area where several spires of tubular steel and plastic stacking chairs are stored between meetings. On the southwest wall, rippled glass windows point towards Battery Park, except a nearby industrial building stands in the way, its valves and ductwork glow milky green both day and night. Pushed against an opposing wall is a heavy wooden table. Above hangs a mirror with a faux gilt frame. The room's

sole purpose on Monday evenings is to accommodate 16 B's ongoing conversations about art and politics, typically accompanied by coffee, fruit, hummus, pita bread and whatever else participants contribute. 16 B also manages a website that serves not only as an organising tool, but as a bibliography of accessible texts and an archive of past discussions and readings from each week, month and year, which accumulates like intricate skeins of shared knowledge.

•

'The real crisis in art education,' artist and cultural entrepreneur Anton Vidokle insists, 'appears to be one of distribution: radical, experimental and advanced institutions are clustered in Europe and North America.'[14] These regions act as magnets for those who wish to participate in advanced art practices and draw dark matter into the global art machinery. Since this comment was penned in 2006, an outpouring of new art academies and schools – some large, some small, some barely visible – have sprung up. Reports indicate that students gather behind the

tenth-floor elevator machine room at London's Central St Martins College of Art to clandestinely reappropriate their education. Beyond this are the Public School, Petersburg Street University, Baltimore Free School, Stockyard Institute and 16 B. Add to the list the School of Missing Studies in the Balkans, Red76's Laundry Lecture Series in Portland, Oregon, transit-free school in Austria and eastern Europe, The School of Decreative Methodologies at Basekamp space in Philadelphia, or artist Nils Norman's University of Trash and Exploding School projects.

The volume of recent, 'bottom-up' pedagogical initiatives becomes clear – often at ever-greater distances from the US-EU art world nucleus. In Ramallah, the International Academy of Art Palestine brings together local students with practicing artists from the region and abroad. Supported with money from Norway, it awards a bachelor's degree in contemporary visual art in a region recently all but exiled in the West as culturally subaltern. Nearby in Beirut, a new art academy is being organised by Christine Tohme, co-founder of Ashkal

Alwan – the Lebanese Association for Plastic Arts – and director of the decade-old Home Works programme. She aims to employ the cultural, political and spatial complexity of the city as both art laboratory and campus. Far from the Middle East (although perhaps politically also quite near) the artists Judi Werthein, Graciela Hasper and Roberto Jacoby have established an art school in Buenos Aires, Argentina. El Centro de Investigaciones Artisticas, or simply CIA, is both informally structured and constantly challenged by a lack of sustainable funding, but each year, the school offers dozens of seminars to aspiring art students.

However, Vidokle may still have the last word: similar to the programmes in Palestine and soon in Beirut, Argentina's CIA turns out graduates in a location with few resources to sustain professional artists once they graduate. Not even the new, networked 'knowledge economy' has made serious inroads into these regions. The reality suggests that even those who pass through these radical programmes will, barring alternative forms of support and encouragement, eventually be drawn

towards the magnetic 'art mountains' of New York, London and Berlin.

A provisional simulation of institutional agency appears to be unfolding, step by awkward step. As in Borges' map, the virtual and actual are superimposed on one another. Although Adorno once railed against the intellectual and artistic banalities of administered culture in the postwar era, perhaps it has become necessary now to occupy the ruins of that former society, or more accurately, to wear its wreckage as a carapace. After all, this accumulated cultural detritus is our history, our dark archive of fragmented knowledge and potential liberation. As students during the 2009 Berkeley occupation lamented, 'This accumulation is our shared history. This accumulation – every once in a while interrupted, violated by a riot, a wild protest, unforgettable fucking, the overwhelming joy of love, life shattering heartbreak – is a muted, but desirous life. A dead but restless and desirous life.'[15] Still, what emerges from the grave is always incomplete, impure, time-sensitive and frequently paradoxical. It leaves one outstanding question above all others: how

might these bottom-up pedagogical experimentation and DIY academies be prevented from becoming part of what the students who occupied UC Berkeley dubbed the 'necrosocial' – a world suited only for the living dead, or what activists in the Occupy movement describe as the intolerable burden of debt that financiers, asset speculators and real estate developers use to fuel their profits.[16]

What we have seen in the past few years – from Berkeley to Cairo, and from Wisconsin to Wall Street – is a materialising force of dark matter: a previously invisible social productivity that confronts capitalism's so-called wondrous future as a grinning, antagonistic corpse, or necrosocial archive that overflows with unspent desire and imagination. Even as the real and digital decay of post-public enterprise culture provides a modicum of protective mediation – a space of temporary rebellions as much as self-education, of mimicry as much as tactical activism – for better or worse, these ruins also continue to remind us of what has been lost and what promises still wait to be fulfilled.

NOTES

1 Jorge Luis Borges, 'On Exactitude in Science,' in *Collected Fictions*, trans Andrew Hurley, (London: Penguin, 1999) 320.

2 Communiqué from an Absent Future, critical theory and content from the nascent California student occupation movement, 24 September 2009: wewanteverything.wordpress.com/2009/09/24/communique-from-an-absent-future

3 From 'A Statement from the Occupy Student Debt Campaign,' occupystudentdebtcampaign.org/click-to-read-our-statement-on-student-debt-reform-initiatives

4 The Public School is part of the Telic institute alternative art centre, but all other 'branch' locations are autonomous: the-flog.com/2008/03/the-public-school-at-telic

5 See the BHQF 'Prolegomena To Any Future Art School' manifesto: bhqf.org/site/about.html

6 Compare the BHQF to the opening lines of the book, *The Coming Insurrection*: 'Everyone agrees. It's about to explode.' (*The Invisible Committee*, Semiotext(e) Books, 2009).

7 The nineteenth-century origins of the art educational 'factory' in the Unites States are neatly mapped in Howard Singerman's opening chapters of *Art Subjects: Making Artists in the American University*, (Berkeley: University of California Press, 1999).

8 Chto Delat/What is to be Done? is a left-leaning Russian artist collective, founded in St Petersburg in 2003. The group borrows its name from Lenin's 1901/2 essay of the same title. The website and archive of political art and cultural newspapers is located at www.chtodelat.org

9 'Street University in Saint Petersburg: a Brief History': streetuniver.narod.ru/index_e.htm

10 Chto Delat, 'A Declaration on Politics, Knowledge, and Art':

www.chtodelat.org/index.php?
option=com_content&view=
article&id=494&Itemid=233&lang=en

11 For some events, the group asks for a modest entrance fee (adjusted for students and unemployed persons) in order to partially cover programme expenses.

12 16 Beaver Street has avoided seeking non-profit status or tax exemption even though the group's programming record as an established New York cultural institution would likely make them a grant magnet.

13 Cited in an email from 16 Beaver Street collective member Pedro Lasch to the author, dated 10 January 2010.

14 Vidokle runs the for-profit art platform e-flux.com and in 2008–9 organised a series of educational seminars, para-fictionally christened 'Night School,' at the New Museum in New York. See: Anton Vidokle, 'Exhibition as School in a Divided City,' *Notes for an Art School: Manifesta 6*, (Nicosia for Art, 2005) 4.

15 'The Necrosocial: Civic Life, Social Death, and the UC, a Communiqué by Occupied UC Berkeley Students,' 18 November 2009: anticapitalprojects.wordpress.com/2009/11/19/the-necrosocial

16 *Ibid*.

Sean Dockray

OPENINGS AND CLOSINGS

In the early morning of 8 November 2011, approximately 400 of São Paulo's military police, armed with tear gas and aided by helicopters, arrested 72 protestors – mainly students – who had occupied the University of São Paulo (USP) rectory to protest the presence of police on campus. The occupation was staged in response to the arrest of three fellow students earlier that year – a consequence of a new contract between university officials and the MP to allow police back onto campus after decades of being barred from entering.

University 'autonomy' was established by Article 207 of the 1988 Brazilian Constitution in an effort to close a chapter on the nation's military rule – an era when Brazil's military police enforced a series of decrees aimed at eliminating opposition to the dictatorship, including the local articulation of the 1960s student movement. Prior to Article 207, the 1964 *Suplicy de Lacerda* law was meant to depoliticise radical student

groups by disallowing the participation of campus organisations in politics; in 1968, Institutional Act No 5 eradicated habeas corpus when the Brazilian Congress was closed by the country's military. One year later, Decree 477 gave university and education authorities the right to expel students and professors involved in protests.

The history of USP's impermanent 'autonomy' is no isolated incident. In Greece, a similar provision of a 35-year 'university asylum' restricted police-access on the country's institutions of higher education. Like Brazil, this measure was adopted after the fall of a military regime that had violently crushed student uprisings. And in 2011, like Brazil, this prohibition on police incursions on campuses collapsed. Greek politicians abolished the law in order to more effectively implement austerity measures imposed by European financial interests.

Militarisation of Campuses and Books

Ten days after the raid at the University of São Paulo, Chancellor Linda Katehi of

the University of California, Davis, ordered police to clear a handful of tents from a campus quadrangle. Because the tents were part of a peaceful demonstration planned in solidarity with other actions on UC campuses inspired by the Occupy movement, law enforcement were able to swiftly and forcefully dismantle the nonviolent encampment. Students were pepper-sprayed at close range by a well-armoured policeman who bore little concern.

Such examples of the militarisation of university campuses have become more common, especially in the context of growing social unrest. In California, they demonstrate the continued influence of Ronald Reagan, not simply due to the implementation of neoliberal policies that have slashed public programmes, produced a trillion dollars in US student loan debt and contracted the middle class; these acts also revisit Reagan's 1966 campaign for state governor, when he first promised to crack down on campus activists, then partnered with conservative school officials and the FBI in order to 'clean out left-wing elements' from the UC system. Not coincidentally, Chancellor

Katehi was also an author of a 2011 report recommending that the Greek government terminate university asylum. The report noted that 'the politicisation of students... represents a beyond-reasonable involvement in the political process' and went on to state that 'Greek university campuses are not secure' because of 'elements that seek political instability.'

After the military police operation in São Paulo, the rector appeared on television to accuse the students of preparing Molotov cocktails. Independent media, on the other hand, described the students as carrying left-wing books. Even more recently, at UC Riverside, a contingent faculty member holding a cardboard shield that was painted to look like the cover of *Figures of the Thinkable*, by Cornelius Castoriadis, was dragged across the pavement by police and charged with the felony of 'assault with a deadly weapon'. In Berkeley, students covered a plaza in books, open and facedown, after their tent occupation was broken up.

Many of the crests and seals of universities feature a book and no doubt draw on the object as a symbol of knowledge and an

actual repository for it. By extension, books have been mobilised in recent occupations and protests to make material reference to education and the metastasising knowledge economy. This use of radical theory literalises an attempt to bridge theory and practice while evoking utopian imagery, or simply taking Deleuze's words at face value: 'there is no need to fear or hope, but only to look for new weapons.' Against a background of library closures and cutbacks, as well as the concomitant demands for the humanities and social sciences to justify themselves in economic terms, it is as if books have come into view, desperately, like a rat in daylight. There is almost nowhere for them to go; in the remaining libraries, spaces have been overtaken by audio-visual material, computer terminals, public programming and cafes, while publishers are shifting to digital distribution models designed to circumvent libraries entirely. Books have therefore come out on the street. When knowledge does escape the jurisdiction of both the state and the market, it's often at the hands of students (both the officially enrolled and the autodidacts). For example, in Brazil the

average cost of required reading material for a freshman is more than six months of minimum wage pay, and up to half of the texts are either out of print or unavailable in the country. A system of copy shops provides on-demand chapters, course readers and other texts, but the Brazilian Association of Reprographic Rights has been particularly hostile to the practice.

One year before the USP arrests, seven armed police officers in three cars, accompanied by the Chief of the Delegation for the Repression of Immaterial Property Crimes, raided the Xerox room of the School of Social Work at Rio de Janeiro's Federal University. They arrested the machine operator and confiscated all illegitimate copies. Similar shows of force have proliferated since 1998, when Brazilian copyright law was amended to eliminate the exceptions that had previously afforded the right to copy books for educational purposes. The act of reproduction, felt by students and faculty to be inextricably linked to university autonomy and the right to education, even coalesced into a 2006 movement, *Copiar Livro é Direito!* (Copying Books is a Right!).

Illicit copies, when confiscated, are usually destroyed. In this sense, it is worthwhile to understand such events as contemporary forms of censorship, certainly not out of any ideological disapproval of the publication's actual content, but rather as an objection to the manner of its circulation. Much of the book banning (and burning) instituted during the dictatorship was obviously implemented due to a matter of content; according to the 1970 Brazilian censorship law 1077, those who could 'destroy society's moral base' might 'put into practice a subversive plan that places national security in danger.' Even if explicit sexuality, crime and drug use in literature are generally tolerated today (not everywhere, of course), the rhetoric contained in the decree that instituted censorship more than 40 years ago is still alive in matters of circulation.

●

During negotiations for the multinational Anti-Counterfeiting Trade Agreement (ACTA), the administrations of both

George W Bush and Barack Obama denied the public information, stating that certain documents were 'properly classified in the interest of national security'. In the United States, politicians claim that protecting intellectual property is essential to maintaining the American way of life. Although today this 'way of life' has less to do with the moral base of the country than the economic one – of workers and corporations. When Wikileaks published excerpts of these negotiations online, ACTA was revealed as a vehicle for exporting American intellectual property enforcement, and in reference to the agreement, Obama said that the United States would use the 'full arsenal of tools available to crack down on practices that blatantly harm our businesses.'

Universities – those institutions designed for the production of knowledge – are deeply embedded in struggles over intellectual property. Moreover, they are deployed as instruments of national security. Several times each year, the National Security Higher Education Advisory Board, which unsurprisingly includes Linda Katehi, brings together select university presidents

and chancellors with the FBI, CIA and other agencies to address intellectual property at the level of cyber-theft (preventing sensitive research from falling into the hands of terrorists). Yet this congenial relationship between university administrations and the FBI raises the spectre of the US government spying on student activists in the 1960s and early 1970s.

Out of such partnerships with the state, the forces of financialisation have been absorbed into universities. Towering US student loan debt is one very clear index; another less apparent but growing indicator is the highly controlled circulation of academic publishing, especially journals and textbooks. Although seemingly marginal (or niche) in topic, the vertical structure of the corporations behind most journals is surprisingly large. The Dutch company Elsevier, for example, publishes 250,000 articles per year and earned $1.6 billion (a profit margin of 36 per cent) in 2010. Texts are written, peer reviewed and edited on a voluntary basis (usually labour costs are externalised to the state or university). They are then sold back to university

libraries at extortionately high prices that libraries are obliged to pay because the university constituency relies on access for further research.

When the website library.nu was shut down for providing free access to more than 400,000 digital academic texts, major 'commercial' publishers were not behind the action. Instead, a coalition of 17 educational publishers – including Elsevier, Springer, Taylor and Francis, the Cambridge University Press and Macmillan – formed an alliance. On the heels of FBI raids on prominent torrent sites, and with a similar level of coordination, the group hired private investigators to deploy software 'specifically developed by IT experts' to secure evidence of publication and access.

In order to expand their profitability, corporate academic publishers exploit and reinforce the entrenched hierarchies of academia. Compensation comes in the forms of CV lines and disciplinary visibility, and it is this validation that individuals need to find and secure for employment at research institutions. 'Publish or die' is nothing new, but the term has grown more

ominous as employment grows increasingly temporary, and managerial systems for assessment and quantifying productivity proliferate. Beyond intensifying internal hierarchies, this publishing situation has widened the gap between the university and the rest of the world (even as it subjects the exchange of knowledge to the logic of the stock market); publications are meant for current students and faculty only, and their legitimacy is regularly checked against ID cards, passwords and other credentials. Those without such legitimacy find themselves on the wrong side of a pay wall.

In the inconveniences of proximity cards, accounts and login screens we discover the quotidian dimension to the militarisation of the university: if our contemporary forms of censorship are focused on the manner of a thing's circulation, then systems of control would be oriented towards policing access. Reprographic machines and file-sharing software are obvious targets, but with the advent of tablet computers (such as Apple's iPad, marketed heavily towards students), so are actual textbooks. The practice of reselling textbooks, a yearly student money-

saving ritual that is perfectly legal under the first-sale doctrine, has long represented lost revenue to publishers. In fact many, including MacMillan and McGraw-Hill, have moved into the e-textbook market, which allows a publisher to shut the door on secondary selling because students are no longer buying the *things* themselves, only temporary *access*.

Opening of Access

Open access publishing offers an alternative in order to circumvent the entire parasitical apparatus and ultimately deliver texts to readers and researchers for free. In large part, its success depends on whether or not researchers choose to publish their work with OA journals or with pay-for-access sites. If many have chosen the latter, it is due to factors such as reputation and the interrelation between publishing and departmental structures of advancement and power. Interestingly, institutions with the strongest reputations are the ones pushing the hardest for more 'openness'.

In 2011, Princeton University formally adopted an open-access policy (the sixth Ivy League school to do so) in order to discourage the 'fruits of [their] scholarship' from languishing 'artificially behind a pay wall.' MIT has long promoted openness of its materials – from OpenCourseWare (2002), to its own open access policy (2009), to a new online learning infrastructure, MITx.

Why are elite, private schools so motivated to open themselves to the world? Would this not dilute their status? The answer is obvious: opening up research gives their faculties more exposure; it produces a positive image of an institution that is generous and sincerely interested in generating knowledge. Ultimately, it builds the university's brand. They are certainly not giving away degrees or research positions. Instead they are mobilising their intellectual capital to attract publicity, students, donations and contracts.

We can guess what 'opening up the university' means for the institution and the faculty, but what about for the students, including those who may not have the proper title, or those learners who are not enrolled?

MITx is an adaptation of the common practice of distance learning, which has a 150-year history, beginning with the University of London's External Programme. There are populist overtones (Charles Dickens called the External Programme the 'People's University') to distance learning that coincide with the promises of public education in a more general way, namely making higher education available to those traditionally without the means for it. History has provided us with less than desirable motivations for distance education (the Free University of Iran was said to have been advantageous to the Shah's regime because the students would never gather), but current western programmes are influenced by other concerns. Beyond publicity and social conscience, many of these online learning programmes are driven by economics. At the University of California, the Board of Regents launched a pilot programme as part of a plan to close a $4.7 billion budget gap, with the projection that such a programme could add 25,000 students at 1.1 per cent of the normal cost.

Aside from MITx's free component (it also brings in revenue if people want to actually get 'credit'), most of these distance-learning offerings are immaterial commodities. The UCLA Extension is developing curricula and courses for Encore Career Institute, a for-profit venture bringing together Hollywood, Silicon Valley and UC Regents chairwoman Sherrie Lansing, whose apparent goal is to 'deliver some of the fantastic intellectual property that UC has.' Even MITx is not without its restricted-access bedfellows; its pilot online course requires a textbook, which is owned by Elsevier. In this sense, students are conceived as consumers of product, and education has become a subgenre of publication.

Today, the classroom and library are seen as inefficient mechanisms for delivering education to the masses, or rather, for delivering the masses to creditors, advertisers and content providers. Clearly classrooms will continue to exist, especially in the centres for the reproduction of the elite, such as those proponents of Open Access previously mentioned. But everywhere else, post-classroom (and post-library) education

is exploding. Students do not gather here, and they certainly don't sit-in or takeover buildings; they do not argue outside during a break over a cigarette, nor do they pass books between themselves. But while networks of access may be managed by capital and policed by the state, I am not a fatalist on this point; new collective forms and subjectivities are already emerging, exploiting or evading the logic of accounts, passwords and access. They find each other across borders and disciplines.

Negating Access

After the capitalist restructuring of the 1970s and 1980s, how do we understand the scenes of people clashing with police formations? The revival of campus occupations as a tactic? The disappearance of university autonomy? The withdrawal of learning into the disciplined walls of the academy?

In short, how do we understand a situation that appears quite like before?

One way – in fact, the theme of this essay – is through the notion of 'access'.

If access has moved from a question of rights (who has access?) to a matter of legality and economics (what are the terms and price for access, for a particular person?), then over the past few decades we have witnessed access being turned inside-out, in a manner reminiscent of Marx's 'double freedom' of the proletariat, in which we have access to academic resources but are unable to access each other.

Library cards, passwords and keys are assigned to individuals; so are contracts, degrees, loans and grades. Students and faculty are individuated at every turn, perhaps no more clearly than in online learning where each body collapses into his or her own profile. Access is not so much a *passage* into a space as it is an *apparatus* enclosing the individual (open access, in access, is one configuration of this apparatus).

In the past seven years I have been involved with two ongoing projects – a file-sharing website for texts, AAAARG.ORG, and a proposal-based learning platform, The Public School. Both attempt to escape the regime of access in order to create room to understand all of these conditions, their

connection to larger processes and possibilities for future action. The Public School has no curriculum, no degrees and nothing to do with the public school system. It is simply a framework that encourages users to propose ideas for what they want to learn. A rotating committee can then organise this proposal into an actual class that brings together a group of strangers and friends who find a way to teach each other.

AAAARG.ORG is a collective library comprised of scans, excerpts and exports that members of its public have found important enough to share. The premise for the library is based in part on the proposition that making these kinds of spaces is an active, contingent process that requires the coordination, invention and self-reflection of many people over time. Their creation involves a negation of access and often enables conflict to surface. Therefore, these spaces are not territories *on which* pedagogy happens; rather, the collective activity of making and defending these spaces *is* pedagogical.

In the militarised raids of campus occupations and knowledge-sharing assem-

blages, the state is acting to both produce and defend a structure that generates wealth from the process of education. While there are occasional clashes over content, usually any content that circulates through this structure is acceptable, and the very failure to circulate (to attract grant funding, attention or feedback) becomes the operative, soft form of suppression. A resistant pedagogy should look for openings – and if they don't exist, break them open – where space grows from a refusal of access and circulation, borders and disciplines; from an improvised diffusion that generates its own laws and dynamics. But a cautionary note: any time new social relations are born out of such an opening in space and time, a confrontation with power is not far behind.

Reference: www.planalto.gov.br

Pablo Garcia, Janna Graham and
Leonardo Vilchis of Ultra-red

WHAT IS THE SOUND OF RADICAL EDUCATION?

The sound-art collective Ultra-red has long drawn on diverse histories in the global field of popular education.[1] One of the group's most persistent debates has been whether education itself serves as a site of struggle or a methodology. We are often asked how the collective determines the political issues on which it launches an investigation into sound, but the notion of 'issues' only ambiguously describes the thematic focus of an enquiry. When it is militant, research develops within and through a base community.

The following text captures a dialogue among three members of the collective – London-based Janna Graham with Los Angeles-based Pablo Garcia and Leonardo Vilchis – on the issue of education in their individual political work.[2] Each person opens his or her responses by playing an audio recording chosen to either exemplify

the sound of radical education or problematise the question of education's role in class struggle.

The encounter excerpted below ignited an urgency within Ultra-red to engage popular education in new ways. In the months that followed this lively conversation, Ultra-red teams in Berlin, London, Los Angeles and New York began laying the groundwork for a pedagogical space we have called the School Of Echoes, which seeks solidarity with base communities that fight against the war on the poor, including those very neighbourhoods where Janna, Pablo and Leonardo work to develop forms of participatory democracy. For the members of Ultra-red, the first step in such a project has been radically altering our notion of who the protagonists of art and of cultural action are, and how this changes the landscape of contemporary activism.

> Dont Rhine, Ultra-red Cofounder
> and Information Secretary

Leonardo Vilchis

I am co-director of the non-profit organisation Unión de Vecinos. My role exists within a network of neighbourhood committees that were initially based in the East Los Angeles neighbourhood of Boyle Heights. Established over sixteen years ago, now we also work with neighbourhood committees in the nearby city of Maywood, where I personally spend most of my time. Outside of work, I am devoted to being a parent and a member of Ultra-red.

The role of Unión de Vecinos is to help community members develop their own processes for affecting the kinds of changes they want to see happen. We start with the community's needs – whatever they are and whatever issues the community identifies as important. Today, this collaboration between the staff of Unión de Vecinos and the residents of Maywood has us engaged in different kinds of processes.

SOUND OBJECT 1
'Eminent Domain' (01.44 min). Recording made on Saturday, 20 May 2011, at the

Unión de Vecinos office in Maywood, California, during a workshop with state water officials

What did you hear?
The event we hear in the recording took place just yesterday. The occasion was a meeting with one of the principal consultants from the Select Committee on Regional Approaches to Addressing the State's Water Crisis. This person works closely with John Pérez, the State Assembly representative for the City of Maywood, who is also the Speaker of the California State Assembly. The water consultant, along with the special legislative assistant to the assembly speaker, had come to the office of Unión de Vecinos in Maywood to meet with our water justice committee. Earlier I had mentioned that the work of Unión de Vecinos involves working closely with neighbourhood committees of local people. The water justice committee in Maywood is one of those groups. What you hear in the recording are these high-ranking bureaucrats teaching a small group of working-class people how they can create a municipal water district in their own

community by taking over the three private water companies that provide tap water to the people in Maywood.

I wanted to start with this recording because, on a lot of levels, this sounds like a typical public hearing. We catch the sound of official voices coming to educate community members about what they can do with their popular power. Leading up to this meeting, residents in Maywood have worked for the past ten years to address the problems with the area's water supply and access. In the average Maywood home, water comes out from the tap the colour of iced tea. It does not matter which of the three private water companies provide the water; all distribute water the colour of tamarindo. The only mechanism by which residents have a voice in the pricing or control of water quality is if they own property. However, 75 per cent of Maywood is made up of renters. Consequently, the one person out of four who owns property decides the quality of water for everyone in the city.

As part of an ongoing community organising process, we sought the support of environmental scientists who could

educate the community on how to participate in testing the contents of their water. For ten years every study demanded more studies. During that entire time no one dared to ask the political question: how do we get beyond the science and take control of the water companies to clean up the water?

For the past two years, the neighbourhood committee organised around the water situation in Maywood has been asking, 'Why don't we take over the water companies?' Since Unión de Vecinos starts with the questions that the community asks, we tried to find the answer. How do the three water companies in Maywood function? What are the legal procedures required for taking them over?

Two years ago, the residents began collecting proxies from property owners to have their voices heard on the policies of the private water companies. Neighbours began talking to one another. Renters began speaking with property owners and asking them to sign the proxy petitions. The residents would then explain to the property owners how the system works and how they were using the proxies to have the right to

vote on the ways that the water companies function. At the end of two years, the residents of Maywood held an election for the board of directors for one of the three water companies. Using the proxies, the residents won five out of five board member seats.

This brings us to the meeting that took place yesterday with the consultants on water from the state government. Here is the irony of the situation: it was during the meeting yesterday that we all learned that residents have another way of taking control of utilities. After 10 years of trying to figure out how to change the water companies and how to improve the quality of the water, we learned in one night that all we have to do is secure petitions from 10 per cent of the registered voters to create a municipal water district. With only 10 per cent of registered voters, residents can identify the utility they want to annex, vote for their own people and then take over the water companies through eminent domain.

What seems to me like an important lesson here is that the state did not talk to us about the eminent domain option until

the community had the power and demonstrated interest. Before that, nobody ever told us that you could actually, by decree, change the ownership, the social and the political structure of the water company. The community had to learn how to take over a water company in order for the state to come and tell us how it really is done. So last night we were discussing how the community can manage the other two water companies and begin to change the water contaminated with TCE, perchlorates, mercury and lead – all of which are carcinogenic and deadly.

 I tell this story as an example of how learning occurs within and through organising work. Learning and organising happen simultaneously. For that reason, the process takes a long time. The community itself takes a long time. As organisers, we also have to contend with the reality that oftentimes, the state already has the tools for addressing the problems, but officials will not sit down with you until people organise and act based on collective power.

Pablo Garcia

I have been involved with Ultra-red from the beginning, and the first piece I did with the group used William Burroughs' cut-up method with analogue audiotape to make a sound collage about needle exchange. Outside of sound work I am an educator. Currently I work with a very old organisation that was started in 1922, called Woodcraft Rangers. The founder of the organisation, Ernest Thompson Seton, co-authored the Boy Scout Handbook. Over the past seven years I have taken over much of the organisation's staff and programme development. This has allowed me to influence the work that we do with popular education practices and principles, which is pretty exciting. At the same time, introducing popular education into this context also has its dangers, notably because the organisation's largest contract for education services is with the Los Angeles Unified School District.

SOUND OBJECT 2
'Different School Completely' (01.16 min). Recording made in Spring 2011, during a

meeting of the Youth Advisory Board at the South East High School in the city of South Gate, California

What did you hear?
While my formal work with Ultra-red has been on something of a hiatus in recent years, I have been completely immersed in this giant non-profit. When I came aboard, Woodcraft Rangers had just received $5.5 million in public funding from LAUSD. The money came with the mandate to serve about 8,000 kids a day in 60 schools across Los Angeles County. To put it mildly, Woodcraft Rangers did not know what to do. The senior staff hired a number of people, including myself, to launch a massive countywide after-school programme. I saw this as an amazing opportunity: a) because [Woodcraft Rangers] did not know what to do, and b) it was going to give me the leverage to hire and train a large group of people and then test the very ideas and practices we had been developing in Ultra-red around popular education.

With public funding, we have managed to enter into communities across the county

and slowly build processes for alternative education. At the centre of these processes, the youth and their families tell us how to use the money we receive from the state. In other words, what we have done far exceeds the goal of babysitting. We work with county youth in investigating the surrounding community and identifying local needs. For example, if you put a group of eighth-graders in a room to talk about issues in the community, they will want to cure cancer and end world hunger. We work with them to think about the steps they can take on a micro-scale. 'Where can we start?' This might mean asking them how far it is to the nearest hospital or health clinic. Asking a very concrete question helps them begin to map the reality around them. Once they imagine an investigation they can reasonably undertake together, we let them control the budget for that school's programme. We let them hire people who will facilitate the programme based on what they – the local youth and their parents – determine to be the content and form of the enquiry for the year. Like Leonardo said when he was describing the work of Unión de Vecinos,

working with all of these communities requires a very long process.

Years ago, Paulo Freire compared the banking method of education with critical literacy. Today, the banking method has been replaced with compliance training. Education administrators talk about the need for dialogue with parents regarding the quality of the education provided by the system. In fact there is no real desire for that discussion even though it is dutifully listed on the agenda of every meeting. We have exactly the kind of education needed for producing mass compliance among poor and working people.

From my experiences with the school system, we have to begin by agreeing that education is a public good. Everyone benefits from a form of education that is meaningful to working class communities as a whole, whether or not someone has children. The quality of the education links directly to the investment of time and participation in the learning process at the level of the entire community. However, there is no place in our society for that conversation.

As for future steps, I would have to say that where we go from here grows out of these same processes I have described. The community-wide learning that happens in the after-school programmes demonstrates the poverty of the formal public education system with its standardised curriculum and teaching to test. The youth and the communities we work with see only two options to change the kind of education they receive. We either take over the school district and wrestle education out of the hands of LAUSD, or we start our own schools. We have so many families now that have been a part of the Woodcraft Rangers processes for years. We have worked with their kids, sometimes for the past seven years. They trust us to listen to them and to do things they want with the resources we have. I feel that we could open schools that build on that history of trust and participation.

Janna Graham

I'm from Toronto, but I have lived in London for the past five years. Lately I have been

working alongside a large number of artists, students and activists to mobilise against the Tory government that came into power in May 2010. Soon after David Cameron's government took office, they decided to slash public funding. Many of us have been out protesting in the streets, attending meetings and feeling exhilarated and exhausted by the constant activity of the past six months.

I also run a neighbourhood arts organisation called the Centre for Possible Studies, which is hosted by the Serpentine Gallery in London.[3] At the Centre, we do a lot of popular education work using the arts. The programming sometimes comes from a community-led perspective; people determine the issues they would like to work on, and how and on what terms these issues find relationships with art. Other times, the programming comes from a very institutional or artist-led perspective. These approaches are quite contradictory in many ways, which speaks to where many UK grassroots initiatives sit in relation to larger institutions. To begin, I want to play a recording made by another member of

Ultra-red, Robert Sember, who is in London right now.

SOUND OBJECT 3
'A Serial-Killer of Culture' (01.27 min). Recording made on Saturday, 26 March 2011, of actress Celia Mitchell addressing an anti-austerity rally in Speaker's Corner, Hyde Park, London

What did you hear?
Hearing this recording reminds me of the extraordinary expectations many people felt on that day, 26 March, in Hyde Park at Speakers' Corner. In the weeks leading up to the mass demonstration against the Tory austerity cuts, we heard a lot of discussion about how this moment could potentially result in the overthrowing of the state, of how Hyde Park could be the Tahrir Square of Britain. The revolution did not happen.

In the aftermath of this moment, the movement began to more emphatically question whether we could really talk about revolution, especially when demonstrations consistently organise themselves around those who speak of the act of 'revolution'

rather than the dynamics between speaking, listening and acting upon the world. Trade unions and party politicians in the UK have taught us to expect a mode of organising people, and that is indeed symbolised by the form of politics ritually enacted at Speaker's Corner and the halls of many art galleries: individuals give talks and rousing speeches on the ills of the world, with little awareness of their own processes of organisation. Beyond the unions, most of us involved with Ultra-red in Britain work with constituencies and against a dominant form of political culture that privileges these areas of spectacular public speech as the spaces in which politics take place.

The image of a crowd in front of a speaker is as present on the radical left as on the right, and it infiltrates many of the spaces zoned for so-called alternative or marxist political struggle. In the case of the recording we just heard, the orientation of the demonstration as it moved toward the park, led to a podium, where people like the actress Celia Mitchell, wife of the late playwright Adrian Mitchell, made speeches. While it was a very nice speech, the situation

reiterates the gap between the grand statements of revolution and the realities of the daily practices in which people are engaged. Throughout Ultra-red's work in the UK we have found this same form of political configuration in the non-governmental organisations that came out of the radical movements of the 1970s. Today, many of these groups are organised around representational models; they speak on behalf of constituencies as organisational concessions to receive institutional funding and validation.

But in this moment of a burgeoning social movement opposed to education cuts, we saw in a flash 30,000 people come out to demonstrate at a time when no one thought anyone in the colleges and universities was politically active. All of a sudden, longer-term activists were confronted with the fact that there was a movement of students – a generation of people who were not already coded by existing dynamics and who, in many cases, rejected them. Many of us who have been involved in education-related activism in London for some years were amazed. Suddenly, we had to invent all

kinds of practices. There were large numbers of students with no access to the knowledge of how to organise resistance beyond these more traditional models. Some students had never heard about the Brixton riots of 1981 or 1995, let alone the Ruskin school of autonomous worker education. Many did not know that Southall had been the scene of major anti-racism activism in the 1970s, and others were incredibly well versed.

Together, students and teachers began to learn that such instances of resistance were also moments to produce collective knowledge and forms of learning. Anti-cuts activities began to circulate around these questions: is there another way of producing learning *as* politics? How can our movement constitute itself around the kind of education we want instead of the neoliberal authoritarian form we had come to know? Are there other economies? Other processes of speaking and listening? Non-hierarchical approaches that can be adopted within struggle? Are there examples that we can resurrect from a barely remembered past of other forms of resistance in the UK? We know from the memories of those who

have been surfacing in this new movement that Britain possesses incredible legacies of popular and worker education. As with many popular global education movements, histories of splits in trade union, marxist and anarchist organisations tell of intense and important struggles around issues of self-education and how the means of speaking and listening are organised. In the early moments of the movement, these histories had to be actively remembered.

Within this burgeoning movement, older activists – many of us with experience from counter-globalisation and other movements of the 90s – dedicated ourselves to working with students and teachers to revisit and invent alternative forms of political practice: how to organise meetings, make decisions quickly, form analyses collectively. We shared what we knew about popular education and popular research strategies. Because no one wanted to return to an education sector formulated under New Labour, many of us contributed our own investigations of how histories of resistance offer different ways of 'doing' politics and organising education. Those histories

stand in sharp contrast to what has become standard practice today: the activist speaks to the state on behalf of the victims of a crime, on behalf of the poor, on behalf of the people who have experienced racism and on behalf of those affected by cuts to education. This 'speaking on behalf of' became a very large issue for student and teacher-organisers to contend with in relation to those organisations that claim to represent them.

Prior to these efforts, and as a result of our work on histories of the radical composer and educator Cornelius Cardew, Chris Jones (another Ultra-red member) and myself joined the Radical Education Forum – a group of teachers and students working across university, secondary and primary-school teaching, along with community workers, further-education teachers and practitioners of autonomous self-education.[4] Initially formed as a reading group about radical education histories, the forum responded to the anti-cuts terrain by running workshops on radical education practices within the occupations, student-movement spaces, art galleries and in activist

areas. We held teach-ins and recorded them with the plan of using this documentation to produce a popular education workbook on the topic of those radical education histories and practices. Each text revolves around a term from radical education, describes its history, plots a specific technique and links that technique to a concrete moment in political struggle. In many cases this latter section draws from our own conversations within the social movement of the present.

From the very beginning, we decided not to make the workbook by compiling individual contributions. Rather, we used the workshops to instigate a collective process of co-learning and co-investigation. Sometimes a single page demanded two group assemblies. But during this time we continually came to an understanding of why and how we need popular education strategies in our movements at this particular moment.

In one session, for example, drawing from the work of Freire and critical literacy movements in Latin America, we used a classic popular education tool: the river. The river is like a collective timeline for charting one's relation to a struggle. Doing

this within the occupation of an art school by 20-year-olds revealed that for some of us, the struggle began in the 1980s or earlier. For others, it had begun the Thursday before. Understanding our relationships to struggle was incredibly important. It brought us together as a group and a movement, and helped us understand that education mobilisations are more than a single-issue or reactive 'student' movement, contrary to the general characterisation that had developed in the media in the preceding weeks.

•

Leonardo Vilchis – I want to pick up on the issue that Pablo raised about whether we should take over the schools or convene our own educational institutions. I see a connection between this choice and what we went through by taking over the water company. While everyone discusses the essence or the nature of the problem, at the same time, everyone continues to drink the dirty water. Returning to the issue of the school system, while everyone discusses what is wrong with education in Los Angeles, young

people continue to drink the dirty education. The dirty education builds up in their veins day after day. Again, in the instance of Maywood and the water, at the same time that we discuss the water crisis, the private companies continue to make a profit doing their own thing at the expense of the health of the community. And the state, which is charged with regulating the utilities, collaborates with the status quo.

Pablo Garcia – It is true that while we debate whether to take over the existing schools or start our own schools, students continue to consume the bad education. In Los Angeles, the students also receive the blame for the bad education. If you attend any public meeting about the crisis in education you are bound to hear people say, 'Well, you know, it's the neighbourhood. What can you really expect from a community like Watts?' Suddenly, a 52 per cent graduation rate seems pretty good. But what about the curriculum teachers are stuck with? Many young teachers enter their training programmes full of idealism. The training programmes prepare them with a range of

instructional modalities and theories about the ways we learn. Many teachers graduate from teacher training with a well-read copy of *Pedagogy of the Oppressed* in their hands. They get into the schools and discover an entirely different curriculum and pedagogy. Then later, they're blamed for that pedagogy when the school's test scores begin to slip. Unlike the example Leonardo was using, in education there is no tangible reality of the water in which you visibly see the harmful pollution. A failed education manifests itself slowly over time.

Janna Graham – It's interesting that Leonardo brings up the issue of our complicity. This theme ran through all three of our presentations. What is our relationship to the state and to its processes? In London, tremendous effort has been dedicated to setting up multiple autonomous spaces in the past few months. It has also been important to occupy the spaces of public education as well as the spaces in which taxes are known to be evaded to set up other forms of education. The new Tory government has aggressively promoted what they call

'the Big Society', an idea that draws from a specific notion of autonomy. The Tories promote community organisations that start their own schools and take over healthcare services. But while the government promotes community control of services, local organisations receive only partial or no support by way of state funding.

For example, there is a proposal on the table to establish free schools. The government will provide funding to any organisation that comes up with an idea for one. The initiative sounds positively progressive and was initially confusing for the left. Of course, you have to come up with private monies to support the initiative and adhere to a lot of regulations. All of this leads to hiring teams of private consultants. Consequently, it is just another instance of public-private partnership in British education.

Within the Radical Education Forum, the politics of complicity often come up in our conversations. We have had many debates around the Tory government's free school and how we might deal with it as educators. What proposal and counter-proposal do we put on the table? On the

surface, we actually want free schools. We think that students, teachers and communities should have control over the curriculum and determine what is appropriate and important to know in relation to their own struggles. At the same time, we don't want our communities or ourselves to do this work without public funding or any sense of an education commons. And importantly, we don't want community autonomy to become a means by which racism, xenophobia, sexism and homophobia become enshrined in schools serving narrower and narrower interests.

Leonardo Vilchis – But we have to recognise the existence of other spaces for learning. The challenge for all of us is to figure out where people learn. And what is there to learn? My point is that in the struggles of Maywood, the place of learning exists outside of the school. It exists outside all of these formal educational systems. The learning that people needed – in order to question, speak and to act – occurred in relation to what the community was living with day after day. For me, the most

important aspect of all the questions we are asking is how an educational system helps the community learn *how* to take control of its own life. What are the mechanisms for doing precisely that? Who does that, and who is the subject of this process?

Popular education aims towards a self-conscious subject who always asks questions and then tests those questions by making changes to the conditions of everyday life. From my perspective, even considering what the residents of Maywood have accomplished over the past seven years, both the community and organisers continue in that place of a struggle that never ends.

In popular education it is also important to understand that as an organiser, you occupy a position that is exogenous to the community. To enter into a community means a part of you always remains outside. As Freire would put it, the popular educator should always understand that he or she is the teacher-student, not the student-teacher. It is crucial to understand that relationship. The issue of trust is in naming that contradiction. While traditional community organisers in the United States have an interest in

creating conflict, they don't interrogate their own conflict in relation to the base. Popular educators have to do just that.

NOTES

1 See Ultra-red, 'Andante Politics: Popular Education in the organizing of Unión de Vecinos', *Journal of Aesthetics & Protest* 8 (Winter 2011/2012). This text is based on transcripts of a 2009 conversation between Ultra-red members Elizabeth Blaney, Elliot Perkins and Dont Rhine on the practice of popular education.

2 The conversation took place on Saturday, 21 May 2011, at the storefront gallery, Outpost for Contemporary Art in the Eagle Rock neighbourhood of Los Angeles and was hosted by artist Ashley Hunt. Special thanks to Ashley Hunt and those who contributed their insights and questions to the conversation: Hector Alvarado from Padres Unidos de Maywood and Unión de Vecinos, curator Daniell Cornell from the Palm Springs Museum of Art, artist Malene Dam, artist and poet Jen Hofer, artist Pedro Lasch, Katy Robinson, Rudy Rodriguez, Yolanda Sotoyo from Padres Unidos de Maywood, Roston Woo, as well as Leonardo's partner Teresa Zarate and their children, Aranza Vilchis-Zarate and Leonardo Vilchis-Zarate.

3 An initial exhibition of projects based at the Centre for Possible Studies were featured in 'On the Edgware Road', 6–28 March 2012, Serpentine Gallery and Centre for Possible Studies, curated by Janna Graham, Joceline Howe, Amal Khalaf, Nicola Lees, Sophie O'Brien and Lucia Pietroiusti.

4 For the collective's engagement with Cardew see Ultra-red, 'Scratching The Surface', *Cornelius Cardew: Play For Today*, eds Kate Macfarlane, Rob Stone and Grant Watson (London: The Drawing Room, 2009): 58–63; and 'The Plan As A Protocol For Listening', *Best Laid Plans*, ed Kate Macfarlane (London: The Drawing Room, 2010): 56–62.

Nils Norman

UNWRITING EDUCATION: ON THE SCHOOL OF WALLS AND SPACE

The School of Walls and Space is a department at the Royal Danish Academy of Fine Arts in Copenhagen, which I have led as a professor since 2008. Instruction at the Academy is still loosely based on a seventeenth-century French model in which an individual artist – usually male – would direct his own school and train students in a master-apprentice relationship. Historically, the students were required to copy and even make the work of their professor as part of their education. Today, how academies choose to employ this authoritarian model of education varies across Europe and depends mostly on how liberal the professor or institution is, and the willingness of students to continue to participate or experiment with this type of education.

In Denmark, education is still free for European Union students, and Danish students receive grants to study. At the

Academy, students can apply at the graduate level without any previous qualifications. This system works alongside an admissions process that requires both the faculty and student representatives to participate in a week of intense debate and voting. Student representatives are present on most of the Academy's committees and boards, including new-faculty hiring committees. This could be perceived as a highly privileged and antiquated system, but in light of the increased exclusivity of art schools in the UK – with fees of up to £9,000 – the situation at the Academy could be seen as an egalitarian utopia.

Traditionally, visual art departments in the United States and Britain have been based around a culture of individual studio practice, where one-on-one studio visits and tutorials supply the main source of student-teacher contact. Of course, there are exceptions: alternative modules, seminars and workshops often add another layer to the school's programme. But in most of the larger art schools where I have taught, a collective process is absent in either the basic structure of the institution or in its

teaching culture. In many cases, even places to meet and socialise are non-existent, or have been rationalised into revenue-generating spaces. One example is London's Central Saint Martins School of Art and Design, where I studied in the late 1980s. The school once housed a large and well-used coffee bar where students from all departments could socialise, interact and party. This important space was unexpectedly closed one summer holiday to create more room for studios – that is to say, areas that would allow the school to bring in more fee-paying students. The new Central Saint Martins building in King's Cross prides itself on its open spatial organisation and flexible 'bookable space' model. This move, as well as the building's overall corporate atmosphere, which is more reminiscent of a large commercial architecture firm than an art school, is an attempt to rationalise the area as part of a broader neoliberal programme of privatisation and social-asset stripping across public institutions in the United Kingdom. These tendencies are coupled with the normalisation of the commercial art market and the active encouragement of

debt-crippled students to go straight into the gallery world, usually via an initial 'alternative' or entrepreneurial phase – ie, exhibiting with friends in empty car parks, shopfronts and squats – where they compete directly with their peers in selling work and brokering transactions. Galleries, fairs and dealers are considered the only places to which artists of any value can or should aspire.

The School of Walls and Space was formerly the department where traditional mural-making, mosaics and stained glass were taught. It is unclear how the School got its name, and it is difficult to find any precise background material on the department's recent history. However it seems that for a period it stood empty, without professors or students. After some time, students began to develop the School as a self-organised free-form class. They organised the education, the spaces and the department's budget by themselves. During this period, the students, who called themselves 'Air Conditioning', developed group projects and invited guests to lead workshops and presentations.[1] One of those guests – the American artist Yvette Brackman – was

invited by the students to be employed as the lead professor of the department. During her nine years at the School, Brackman and the students developed an interdisciplinary programme of education that led to numerous collaborations and projects, which included participating in the 2003 Venice Biennale with the American artist Martha Rosler, as well as semester-long seminars with artists Julie Ault and Rirkrit Tiravanija.

With Brackman's support, the students successfully argued to turn the full-time professor post into an 80/20 split, making it similar to the German model in which a professor employs a teaching assistant who is either a student or a practicing artist. The distinction here was that the other 20 per cent was a teaching position in its own right, which allowed for the creation of a close collaborative micro-faculty within the monolith of the traditional professor-school model, thus enabling the programme to break away from the master-apprentice tradition. This structural intervention is an interesting model not only for education in already existing art academies, such as the one in Copenhagen, but also for new

independent initiatives. Its implementation has helped the department immensely by cultivating greater autonomy and opening up possibilities for interdisciplinary approaches. We are able to invite individuals and groups to teach regularly, and we also invite other guests for weeklong seminars and workshops across the academic year.[2]

Unlike conventional programmes, all students at the academy are mixed together, with BA and MA students working side by side on projects, reading groups and seminars. Most group activities, meetings, dinners and workshops happen in the main rooms of the school, but students also maintain individual studio spaces in another building where they develop projects and art pieces either in collaboration or on their own.

The department's autonomy and strong tradition of collective and student-led learning is unusual in an art school, and it is something we have tried to continue, reinforce and expand together. Considering the culture and tradition of the department, and the expectations of students who want to study here, a more traditional approach

would in fact be impossible. This is not a situation I have 'allowed' to happen but is a culture that was already in place when I arrived. Since starting as a professor at the Academy, I have tried to act more as a facilitator or supporter of the students' pursuit of learning – directing activities and advising while trying as much as possible to develop a student-led learning environment.

As a group, we look closely at writers, artists and radical educators including Colin Ward, bell hooks, Yvonne Rainer, Paulo Freire, Augusto Boal, Henry A Giroux, Paul Goodman and Ivan Illich, whose ideas are invaluable resources for developing other types of education and learning activities. Institutions, organisational structures and cultures – such as Black Mountain College, the Summerhill School, the self-organised schools established during the Paris Commune and the Spanish Civil War, the La Borde clinic and the City as School movement, among many other examples – are important places from which to learn, especially since they are based on different ideas, ideologies, intentions and proposals.

Recently we have been looking at the early feminist movement of the 1970s in the United States, with attention to how feminists spoke together, made decisions and organised. Group and play therapy as well as games, gestures, rituals and routines are interesting methods to explore; we have worked closely with the writer and researcher Howard Slater in developing therapeutic interventions in our collective everyday school activities. Past workshops have also involved figures such as Anthony Davies, Emma Hedditch and Silvia Federici to explore ideas around the neoliberal city, gentrification, art and regeneration, austerity in education, social movements, ways forward and ways of becoming. Over the years, my role as an ongoing participant has remained a constant that is continually addressed through relations of power as well as repetition of various normative behaviours and routines, and as paid faculty. However, the consistency has proven to be beneficial in a place as shifting, dynamic and fluid as an art institution and classroom.

As a department, the students and I spend the first few months of the autumn

semester discussing the year ahead, sharing themes and interests, and deciding the academic programme. Unlike other art schools and academies where budgets are managed by the central administration, we have full control over how our money is spent. All students know the department's operating budget and I administer it in close discussion with them and with the help of a school secretary.

The budget is open for students to apply for group and individual funding, and to develop self-initiated workshops through a series of school meetings where decisions are made as a student group using a consensus-based method. Each month is structured around two weeks of workshops and seminar activities: readings, presentations, individual and group presentations, evaluations, dinners and site visits. The other half of the month is usually left unstructured.

•

Student-led education and critical pedagogy have a long and rich tradition within anarchism and elsewhere, but it has been

marginalised by many in academia as a kind of wooly, hippy-type activity with no real educational value. In *Teaching to Transgress*, bell hooks describes the problems and hostility she and colleagues experienced trying to bring learning-centred education to their classrooms. She questions the normative behaviour, racism, sexism and authoritarianism inherent in educational institutions. This can be read as a fear many teachers have of losing their already diminishing power – particularly in light of faculties that must relinquish whatever control they do have to ever-increasing administrative forces, budget restraints and 'resourcing' or fundraising obligations.

At the same time, in today's bleak neoliberal teaching landscape – particularly in the United Kingdom, where extreme cuts in higher education are combined with higher student fees, increasingly impermanent contracts, precarious working conditions and fewer student-to-teacher hours – student-led learning has ironically come back in vogue. It returns not as an emancipatory social process that looks critically at authority and institutional power structures through

self-reflexive action, discussion and participation, but as an ideological sticking plaster similar to the British Conservative Party's right-wing concept of a 'Big Society', where we are all expected to pay for our own self-exploitation within the privatised ruins of the welfare state. Cash-strapped schools are slowly and quietly implementing student-led learning methods as a means of justifying a decrease in facilities, tutors and staff. Concrete examples are visible at Central Saint Martins, where third year students have been asked to develop their own programme of guest speakers because of a lack of critical studies teaching. At Birkbeck College, 'exploring the possibilities of self-determined learning' and 'enhancing flexible learning' is administered through a series of five school-led sessions with cream teas. Both trends misappropriate the term 'student-led' and simply use it as an excuse to justify reductions in staff and space. But once self-guided learning is validated by an institution in even the most rudimentary and misunderstood form, it opens up a rare opportunity for students to activate the moment and space to develop

a properly engaged, collective critical analysis of how decisions are made in their institutions, how they are taught, what the working conditions of faculty and staff are like, how students learn together and to what ends, and how they can begin to change it for their own needs.

Many of the students who have attended the department in Copenhagen have been involved in local activism and politics, particularly with issues of gentrification, immigration and asylum in Denmark. The department has tried to support these activities by strengthening the discourses and vocabulary around them with workshops developed alongside other institutions, and with a network of international guests. For some years, a permaculture course ran in parallel to the regular teaching activities at the department.[3] This became a great source of inspiration and ideas, as it offered a way of looking at cultural production from a socially sustainable and ecologically integrated perspective.

The questioning of power structures and the social reproduction of space and society are also key themes that are

constantly being unpacked and reassembled. This has led to a heightened critical awareness of what an artist is and what artists do once having left art school. General departmental culture, including its research projects and various group discussions, has also enabled an exploration of both the different types of education and the institutional settings in which learning and teaching occur in opposition to the neoliberal business-as-usual perspective that many art schools and faculties have now taken on board.

The contradictions inherent in this situation are obvious, but within them are the seeds of possibilities that, however small or fleeting, can be utilised when students, lecturers and professors have the right processes in place. In Copenhagen, a series of academy-wide student protests and assemblies have been informed by smaller activities and research projects in recent years, particularly around the Bologna Agreement and budget cuts. As an outcome, students have successfully demanded a new democratic process within the institution. The whole academy's decision-making structure – the education

it offers, as well as the design and usage of space – will be challenged, deconstructed and rethought. Real alternatives will be proposed. This move has come directly out of a student-led learning culture that has slowly spread and developed throughout the Academy.

NOTES

1 Students who have had a role in shaping the department since 2008 include: Sarah Sillehoved Allagui, Hannah Kirstine Anbert, Martin Falle Andersen, Julie Riis Andersen, Camilla Bachiry, Verena Becker, Katherine Ball, Jean-Pierre Bertrand, Kristian Byskov, Aurelien Cornut-Gentille, Mia Edelgart, Pia Eikaas, Anne Sofie Fenneberg, Anne Nora Fischer, Jonas Frederiksen, Matilde Westavik Gaustad, Owen Griffith, Martin Haufe, Benny Henningsen,

Deirdre Humphrys, Andreas Johansen, Margarita Torrijos Krag, Cecilie Beck Kronberg, Bjarke Hvass Kure, Line Larsen, Tassilo Letzel, Claudia Lomoschitz, Lucas Wichmann Melkane, Maja Moesgaard, Vebjørn Møllberg, Trine Munk, Sofie Nielsen, Mathias Dyhr Nielsen, Mateusz Nowak, Anna Ørberg, Thomas Bo Oestergaard, Rasmus Pedersen, Stefan Pedersen, Philip Pilekjaer, Ninna Poulsen, Aurore Salomon, Augustus Serapinas, Max Schmölz, Vladas Suncovas, Mathias Toubro, Sharita Towne, Tine Tvergaard, Joen P Vedel, Ester Vilstrup, Anders Waagø, Katarzyna Winiecka and Anna Zwingl.

2 Guests and collaborators with the department include: Julie Ault, Martin Beck, Franco Berardi, Madeleine Bernstorff, Iain Boal, Mikkel Bolt and Jakob Jakobsen, George Caffentzis, Curatorial Action, Anthony Davies, Anna Davin, Silvia Federici, Luca Frei, Sidsel Meineche Hansen, Emma Hedditch, Brian Holmes, Stewart Home, John Jordan, Lasse Lau, MayDay Rooms, Learning Site, Openhagen and Howard Slater.

3 From 2008–10, the School of Walls and Space developed and ran a parallel permaculture design course led by Poul Erik Pedersen (Landskabarkitekt, mdl). Past and ongoing themes include: Permaculture and the City; Politics and Art; Culture and Gentrification; Post-capitalism and Therapy; Self-organisation and Counter-culture; Bioremediation, Food and Fermentation; Alternative Education and Utopia.

Jakob Jakobsen

THE PEDAGOGY OF NEGATING THE INSTITUTION: REFLECTIONS ON THE ANTI-HOSPITAL AND THE ANTIUNIVERSITY

In 1962, a group of people at the Gorizia Mental Hospital in Northern Italy were dismantling the fence that surrounded the institution. Footage from a documentary by the Italian filmmaker Sergio Zavoli shows what appears to be patients and staff cutting and pushing over sections of the high metal fence – one built with the clear purpose to not only demarcate a specific area of a building, but to keep people from getting over and beyond. The films shows, significantly, that the fence that defined the boundary of the hospital is being dismantled from inside the compound, and the faces of those pushing each segment of it to the ground express relief, even joy. In Italian, the voiceover of the film describes the action:

In November 1962, the psychiatric team directed by Dr Franco Basaglia opened up

the first ward of the hospital and inaugurated a therapeutic community. Hospital life will be regulated by ward assemblies and by general assemblies. The patients are regaining a human and social role, as they get to take care of themselves and their existence through an ongoing communication with the people treating them. Once the prison-like nature of the institution has been abolished, the nature of its ideology can be studied.

Dr Franco Basaglia had been named director of the Gorizia Mental Hospital the year before. He initiated the demolition of the containment structure devised to keep the patients inside the hospital, which had been, according to the new director,

Footage of the fence around Gorizia Mental Hospital in Italy as it is being dismantled, 1962

operating more like a prison camp than a place meant for treatment and care. The fence was not just there for the sake of the patients; it existed to protect society from the insane and insanity. Now the fence was coming down.

Basaglia and his colleagues helped make up a broader and diverse movement that was developing across Europe in the early 1960s, which called for the 'deinstitutionalisation' of mental hospitals, as well as other institutions that characterised western industrial societies at the time. In mental hospitals, doctors, nurses, staff members and patients had fixed and static positions within an extremely hierarchical and authoritarian command structure mainly defined by the confinement and violent treatment of patients. Institutional modes of production enforced certain hierarchies and reproduced certain subjectivities within these hierarchies: doctor, teacher, student, patient, convict, guard, soldier, commander, judge, policeman, criminal and so on. For Basaglia, institutionalisation mirrored a society that believed it needed to exclude and isolate 'unproductive'

subjects behind a system of locked doors and high fences as a means of protecting and stabilising its own social relations and modes of production.

The contemporary struggles against neoliberalism in the field of education have much to learn from the struggles within mental and educational institutions of the 1960s. I believe there are structural similarities and interconnections between the various forms of institutional production in education, health, law and order, and urban planning. The struggles catalysed by these social crises of the past and present ultimately take place along the same fault lines. I am especially interested in the most radical currents of the 1960s struggle: the anti-institutional movement that fought for the dismantling and destruction of the outdated and violent institutions of its time. Theirs was not a call for reform; the movement believed the only way forward was to leave these sites of social reproduction altogether, and through experimentation and improvisation, open the way towards the formation of truly democratic and new institutional structures.

Deinstitutionalisation: Two Experiments

In a speech at the 1964 First International Congress of Social Psychiatry in London, Basaglia quoted from the 1925 manifesto of the revolutionary surrealists to attack the directors and doctors working in mental institutions and their relationship to patients: 'Tomorrow morning, at visiting time, when without any lexicon you try to communicate with these men, you will be able to remember and recognise that, in comparison with them, you are superior in only one way: force.' The title of Basaglia's speech was 'The destruction of the mental hospital as a place of institutionalisation: Thoughts caused by personal experience with the open-door system and part-time service'. By dismantling the fence around of the hospital in 1962, Basaglia hoped to initiate the process of developing a new lexicon of madness. Acknowledging the many unknowns of deinstitutionalisation, the development of the missing lexicon highlighted by the surrealists could only be developed through an experimental process: the

fragile, stuttering language implied in not knowing what would happen when the fences of the hospital were taken down.

Basaglia and his colleagues' push for deinstitutionalisation in Italy led to a fundamental redefinition of mental care and institutional control on a national level with the 1978 introduction of Lex 180, also called Lex Basaglia. The law called for the termination of all traditional large-scale disciplinarian mental hospitals. Now that the fence had come down, it was essential that mental illness be recognised as a state of being *within* society and not only attached to specific bodies who were put away as a consequence. Gradually, so-called 'therapeutic communities' were being developed

Clusters of beds and chairs near the remains of the old Gorizia Mental Hospital, 2010

inside formerly sealed-off institutions but also outside of them, in the social fabric, with the establishment of day centres and smaller care homes. These emerging communities were part of a process of inventing and introducing new terms for the lexicon of madness into society.

Across Europe during the early 1960s, the movement for deinstitutionalisation unfolded in diverse ways. By 1962, one year after Basaglia's takeover in Gorizia, some particularly radical initiatives came to light: one on the British Isles, where Dr Maxwell Jones was director of the Dingleton Mental Hospital in Scotland, and another inside Shenley Mental Hospital in England, where Dr David Cooper had established Villa 21. The Dingleton Hospital had implemented an open-door policy for more than a decade. This, combined with Maxwell Jones' goal to integrate care into the wider community, opened new perspectives. Basaglia and his colleagues were aware of these strategies and were discussing Jones' texts on community care. The initial step was to take down the fence and open the locked doors and gates of the mental hospital. The

next step was to dismantle the authoritarian command structure that had until then regulated the patients and ensured their confinement. For Jones, the authoritarian command structure of the mental hospital was not only reproduced in relationships with patients, but on all levels of the institution. This culture had to be challenged and changed. He believed it was necessary to develop new structures and routines of decision-making capable of transforming the way agency worked on every organisational level. Jones proposed a committee structure for doctors, nurses and other staff with high degrees of autonomy in relation to his own position as hospital director.

At Shenley Mental Hospital, David Cooper's method for Villa 21 was more improvised and directly anti-authoritarian. Here, doctors and nurses were asked to take off their white uniforms, and decisions were made in daily community meetings that included all patients and on-ward staff. Villa 21 was developed parallel to the dismantling of the hospital in Gorizia; Cooper was also breaking down structures of separation and moving towards the creation of a context for

a therapeutic community as an insular villa inside the massive Shenley Mental Hospital. With 2,000–3,000 patients at Shenley Mental Hospital, Villa 21 was becoming an experimental zone through the negation of the hosting institution that surrounded the building. The hierarchies between staff and patients were made increasingly porous, and to a large degree, broken down. In their plain clothing, doctors and nurses were asked to step back from learned procedures of intervention, surveillance and control. Instead of tying patients to beds or locking them up behind closed doors, a fluid and communal 'everyday' was developing. Although they could not always avoid friction or conflict, this community of patients and staff operated as an experimental social space for the organic articulation of a new language.

A day at Villa 21 was organised between scheduled and spontaneous group assemblies. The key gathering was the daily community meeting, which ran from 9.45–10.30 each morning. This movement towards communitarian care and mutual support also included programmed group therapy. The new culture also encouraged

patients and staff to establish self-organised and spontaneous groups 'at any time of the day or night around some particular issue – anything from discussion of a television programme to attempts to deal with disturbing acting-out on the part of some patient.' But for Cooper, the ultimate goal was still, as he wrote in his 1967 book, *Psychiatry and Anti-Psychiatry*, to 'step out of the mental hospital into the community.'

In 1965, Cooper and his colleagues of the Philadelphia Association took the step through the establishment of Kingsley Hall in Bow, East London. This groundbreaking move towards the building of an anti-institution – or more specifically, the anti-hospital – was one of the first attempts to organise a therapeutic community independent of any official body. In fact, Kingsley Hall was seen as a space for the reinvention of the hospital as the *negation* of itself. Many of the psychiatrists involved – Dr R D Laing, Dr Joseph Berke, Dr Leon Redler and Dr Morton Schatzman – moved into the building alongside those who felt the need to live in a self-organising therapeutic community. An everyday setting was sought in an impover-

ished neighbourhood of London in opposition to the convention that mental hospitals should be located out of sight and in the city outskirts. Therefore this inner-city neighbourhood became the setting for the experiment of not only deinstitionalisation, but also despecialisation. Medical professionals had to rethink their profession as doctors. And those suffering from mental distress who sought refuge at Kingsley Hall also had to despecialise in relation to their former roles as patients. The kind of 'everyday' that emerged through this setup has been a source of debate ever since, but in hindsight there is little disagreement that this was an experiment with a revolutionary perspective. The language of madness is a social and political relation that Kingsley Hall challenged through social struggle and experimental negation.

From Anti-Hospital to Antiuniversity

In 1965, after arriving from New York, where he had helped to set up the Free University of New York, Dr Joseph Burke moved into

Kingsley Hall. As soon as he arrived Berke recognised Kingsley Hall as an educational anti-institution, and to him, it was already a free university. Berke organised Saturday lectures on politics and culture, drawing especially on his links to the counter-cultural scene in London, as well as the group of political theorists around the *New Left Review*. In November 1965, Berke invited key cultural and political agents from London to a meeting at Kingsley Hall to discuss setting up the Free University of London. This meeting was organised in collaboration with the visual artist and underground publisher Jeff Nuttal. However the Free University of London did not finally materialise at Kingsley Hall, due to objections on the grounds that it would shift the focus from its main activity as a therapeutic community. For Berke the educational aspect was central to the therapeutic community, as it could potentially open up the anti-institution to a broader social reality. As he saw it, the therapeutic community was a learning community and vice versa.

By following this insight, the group of psychiatrists began applying and expanding

the organisational and institutional experiences of the anti-hospital to the university, or the anti-university. This initiative had already begun to take shape at the 1967 International Dialectics of Liberation Congress, organised under the auspices of the Institute of Phenomenological Studies. Although some initial free university activities were already informally taking place at Kingsley Hall, in 1968 Berke and his colleagues established a separate educational initiative as an anti-university. On 12 February 1968, the Antiuniversity of London opened its doors at 48 Rivington Street in East London, in a building cheaply rented from the Bertrand Russell Peace Association. It was basically structured like the Free University of New York but also drew on the experiences from Kingsley Hall and the other anti-hospitals that the group of psychiatrist had been involved with since 1962. As Berke told me in a recent interview about the Antiuniversity, 'In the process of making an institution we deinstitutionalised ourselves.'

The first catalogue of the Antiuniversity of London offered more than 30 courses on a diverse field of topics. A group of tutors

affiliated with the *New Left Review* ran classes in political theory and revolutionary movements. Avant-garde artists such as John Latham, Gustav Metzger, Anne Lockswood and Cornelius Cardew taught courses that consisted of collective and practical experimentation through the making of artistic work. A group of poets and writers including John Keys and Lee Harwood offered anti-courses in poetry. The founding group of psychiatrists and psychoanalysts – David Cooper, Leon Redler, Joseph Berke and Juliet Mitchel – taught courses that covered aspects of psychiatry and experimental therapy along the lines of their critical social perspective. Black Power, experimental drugs, printmaking and underground media were also

Chairs at the Antiuniversity of London, 1968

topics of learning. Alexander Trocchi offered a course with the title 'Invisible Insurrection', which referenced his 1962 text on the founding of a spontaneous university. The poet Ed Dorn declared simply in his course blurb that he would 'be ready to talk to anyone who wants to talk to me'.

The Antiuniversity of London consisted of a very short and explosive process of deinstitutionalisation. The main educational project of the Antiuniversity became, almost from the start, a continuous structuring and restructuring of itself. Many of the people who had lived or were living at Kingsley Hall joined classes with students from the London School of Economics as well as the other official universities across London. Artists and dropouts from the counter-culture scene supplemented the group that signed up, and more than 200 participants enrolled for the first quarter. This proved to be an explosive mix of students in terms of social experiences and revolutionary aspirations, which broadened the community and sustained its aims of collectively constructing the Antiuniversity of London. As an open-ended process that integrated deinstitution-

alisation and despecialisation, the notion of 'teachers' and 'students' (and whatever other social roles that came to mind) were continuously contested.

The second catalogue produced by the Antiuniversity introduced a series of meetings called the 'Counter University'. These focused on the development and operation of the Antiuniversity itself. In May 1968, the group held its first assembly and distributed a flyer with the heading 'You and the Anti-U', which continued the debate around the organisational issues that had been challenged since the first days at the Antiuniversity. It stated:

These past four months have proved that an antiuniversity can survive – it can even grow. The question is in what direction? We feel it is necessary to depass our birth and commit ourselves to a new community development. Any organisation which wishes to be meaningful, not only to the world outside but more importantly, to its self, must re-examine itself at each step. To do otherwise is a symptom of death.

The three main questions on the agenda were the student-teacher relationship, decision-making power within the organisation and the level of communication and exchange between courses. The flyer also called for an end to the distinctions between 'students', 'teachers' and 'administrators'.

The process of pushing for a deinstitutionalisation of the Antiuniversity eventually led to a slow erasure of its original structure; the project dissolved into surrounding social organisations and vice versa. In spring 1968, the Antiuniversity had turned into a commune where many of the students integrated living, learning, education and the everyday in one space. The course structure was dismantled, and by 1968 the building in Shoreditch had been given up. An announcement was made in the underground paper *International Times* (*IT*) with a rather cryptic but telling 'message from nowhere': 'The Antiuniversity is dead. Long live the Antiuniversity!' After leaving the building at Rivington Street in August, meetings continued to take place in private homes and pubs around London, coordinated through a phone line and advertisements in *IT*.

Through its process of deinstitutionalisation and despecialisation, the Antiuniversity of London shifted from a rather centralised structure to an almost invisible self-organising anti-anti-university that occurred whenever and wherever. The last trace of the Antiuniversity I have found is a 1971 advertisement in *IT* for a weekend workshop on poetry and philosophy. In principle, the Antiuniversity continues today, whenever people meet and share critical knowledge and revolution in their everyday. The act of convening doesn't even need to be acknowledged as such.

Leaving and Learning

These radical strategies of deinstitutionalisation could be applied to a contemporary institutional context. Recently, a friend of mine showed me images from the widespread student protests that have gone on in Chile since 2011. The anger and frustration expressed by students arises from the social and economic exclusion brought about by years of increasingly neoliberal privatisation

policies within the educational system. From this, a two-tier educational system has developed: one for the rich and one for the poor. These protests are not due to a recent wave of privatisation as seen in Europe; the Chilean educational system has been heavily privatised for decades, especially through the targeted attack on public education during times of the Pinochet dictatorship. Instead, these protesters fight against *the consequences* of privatisation. They demand free education for all.

Privatisation of education in Chile and elsewhere has far-reaching social consequences. On a general level, universities are becoming increasingly privatised and corporatised as wildly branching industries that serve economic interests not only in relation to the education of the students, but also in relation to research, student credit services, workforce qualifications and urban development. All this is still mediated by a state that facilitates and supports a free-market dynamic inherent to its development. The consequences are felt by students in their daily life: their social futures are being privatised as they become increasingly

responsible, on an individual level, for the socioeconomic sustainability of their education in terms of employability in the labour market and management of the debts imposed by university fees.

Privatisation in Chile has occurred on all levels – not just in the area of higher education. In high school, students also fight against the capitalisation of education and degeneration of public institutions. The images I was shown were from high school occupations, mostly in Santiago, where pupils had fortified the fences of their schools with chairs from classrooms. The images depict chairs toppled upside-down so that legs become spikes to make the already heavy metal fences look even more

Chairs up against a fence at the Universidad de Santiago de Chile, 2011

threatening. It is as if they are warding off any menace of the outside world that wants to storm the compounds of the schools – a desperate attempt to avoid the total abolition of public education. Other images show how chairs are used by university students to build barricades to hinder access of the authorities into the occupied educational institutions.

●

The images of Chilean student protests have made me reflect on how institutions are always organising our bodies, making them stay behind fences; making them sit in certain positions on chairs in the auditorium; making our bodies get out of bed and go to school in the mornings; keeping them fixed and confined in the straitjacket inside the mental institution; this is the way institutions are constantly moulding and remoulding our bodies throughout our lives. What we see in recent developments – which has become evident as students have reacted across the globe – in Montreal, in Santiago, in California, in London – is a more subtle but still uniform

treatment of bodies defined by the interests of capital. The biopolitical moulding of bodies integrated with a crude sorting mechanism determined by economic powers and class has become an increasingly transparent and evident worldwide process. What was formerly a part of social reproduction has become an important aspect of capitalist production, turning it into an expanding site of accumulation. This is perhaps the main structural change from the institutional landscape of the 1960s. There is nothing surprising to this, yet more people, even within the middle class bracket, are feeling the innate sorting mechanisms imposed by the institutional production of today as they enter the educational system.

In stating that there were two kinds of psychiatry – one for the rich and one for the poor – Dr Franco Basaglia foresaw today's biggest issue in education. At the time, he rejected any demands for reform, and his analysis led to a call for 'The Destruction of the Mental Hospital as a place for institutionalisation'. Joseph Berke's analysis of the state-sanctioned university, which led to the establishment

of London's Antiuniversity was radically similar:

The schools and universities are dead. They must be destroyed and rebuilt in our own terms. These sentiments reflect the growing belief of students and teachers all over Europe and the United States as they strip aside the academic pretensions from their "institutions of higher learning" and see them for what they are – rigid training schools for the operation and expansion of reactionary government, business, and military bureaucracies.

Admittedly, it is difficult to compare the socio-economic contexts of 1960s UK and Italy with the present conditions of the globalised economy. One could question what the subsequent deinstitutionalisation of the mental hospitals across the western world has led to, beyond offering the neoliberal ideologists of the 1980s an easy way to cut down public expenses on mental health. But on an institutional level, one could also ask what present-day corporate educational institutions are doing to our

bodies and by extension, to society, and whether there are any good arguments that back a struggle for the reform of an increasingly coercive, exploitative and class-based educational system. Maybe it is time to push for deinstitutionalisation once more in the radical sense of the concept that Basaglia and Berke put into practice. The reverse-use of chairs as a means to obstruct the reproduction of an evermore corporate educational system is a start, but perhaps it is time to simply leave the institution altogether. We can push for student-controlled learning communities to be developed elsewhere and constitute a radical pedagogy towards a new social reality – an anti-pedagogy, to be more precise.

BIOGRAPHIES

FRANCO 'BIFO' BERARDI
Franco 'Bifo' Berardi is an Italian writer, media theorist and activist. An important figure in the autonomia movement, Bifo was also involved in the pirate radio station Radio Alice, based in Bologna. His books include *Precarious Rhapsody* (Minor Compositions, 2009) and *The Soul at Work* (Semiotext(e), 2009). Bifo is also a co-founder of the European School for Social Imagination (SCEPSI).

SEAN DOCKRAY
Sean Dockray is an artist and founding director of Telic Arts Exchange, a non-profit arts organisation in Los Angeles. With Telic, he initiated The Public School, an online platform for self-organised learning, and AAAAARG.ORG, an open text archive.

GREG SHOLETTE
Greg Sholette is an artist and writer based in New York. He is a founding member of Political Art Documentation/Distribution (1980–1986) and REPOhistory (1989–2000)

and author of *Dark Matter: Art and Politics in the Age of Enterprise Culture* (Pluto Press, 2010).

NILS NORMAN
Nils Norman is an artist living in London, whose work spans public art, architecture, and urban planning. He is a Professor at the Royal Danish Academy of Fine Arts, Copenhagen, where he leads the School of Walls and Space.

ULTRA-RED
Ultra-red is a collective that uses sound-based research to directly engage in political struggles. Originally founded in 1994 by two AIDS activists in Los Angeles, the collective now includes ten members across North America and Europe. Their work has addressed the struggles of migration, anti-racism, participatory community development, and the politics of HIV/AIDS.

JAKOB JAKOBSEN
Jakob Jakobsen is an artist, educator and activist based in London and Copenhagen. He was part of the Copenhagen Free

University (2001–2007) and he took part in And And And / dOCUMENTA 13 with his ongoing research project on the Antiuniversity of London (antihistory.org). He is currently working with the Antiknow Research Group at Flat Time House.

TIM IVISON

Tim Ivison is an artist and writer based in London. He is currently completing his PhD on biopolitics in the history of British town planning at The London Consortium, while independently lecturing and curating. Alongside this research, he maintains a collaborative art practice with Julia Tcharfas, showing with Hilary Crisp, London.

TOM VANDEPUTTE

Tom Vandeputte is a writer and editor based in London. He is currently a PhD candidate at the London Consortium, Birkbeck College. Vandeputte is also a visiting lecturer at the Free University Amsterdam and a theory tutor at the Sandberg Institute, teaching courses in critical theory, continental philosophy and media studies.

COLOPHON

Contestations: Learning from Critical Experiments in Education
Editors: Tim Ivison & Tom Vandeputte
Copy editor: Sarah Handelman
AA Art Director: Zak Kyes
Design: Wayne Daly
Printed in Belgium by Cassochrome
ISBN 978-1-907414-23-7

© 2013 Bedford Press and the Authors. No part of this book may be reproduced in any manner whatsoever without written permission from the publisher, except in the context of reviews.

Bedford Press, AA Publications Ltd,
36 Bedford Square, London WC1B 3ES
www.bedfordpress.org

Bedford Press is an imprint of AA Publications Ltd, which is a wholly owned subsidiary of the Architectural Assciation (Inc) Registered Charity No 311083. Company limited by guarantee. Registered in England No 171402. Registered office as above.

ACKNOWLEDGEMENTS

This project has been generously supported by The London Consortium and Fonds BKVB (Netherlands Foundation for Visual Arts, Design and Architecture).

Special thanks to:
16 Beaver Group
Amara Antilla
Matthew Charles
Ben Cranfield
Francesco Garutti
Stine Hebert
Brian Holmes
Dorine van Meel
Kasper Opstrup
Dont Rhine
Victoria Ridler
Paige Sarlin
Brett Steele
Bernard Stiegler
Julia Tcharfas

APPENDIX

164 & 165: 'A' Course
Initiated in 1969, the 'A' Course was an experiment at
Central St Martins School of Art and Design in London.
Working with a variety of rules and staged situations,
the 'A' Course can today be regarded as a salient example
of the recurring attempts by art educators to catalyse
a pedagogical turn from within the institution.
Courtesy John Burke Collection, MayDay Rooms

166–169: Antiuniversity of London
Print ephemera from the Antiuniversity of London,
founded by Joseph Berke, Allen Krebs and others in 1968.
Based on principles of self-organisation and communal
living, the Antiuniversity aimed to eliminate traditional
institutional structures and to abolish the distinctions
between students, teachers and administrators.
Photo Jakob Jakobsen, courtesy PETT Archives

170 & 171: Free International University
The Free International University was founded in 1973
by Joseph Beuys, Klaus Staeck, Georg Meistermann, and
Willi Bongard. As Beuys argued in 1978, the various crises
of his time (military, ecological, economical) required the
question 'What can be done?' to be substituted by another
one: 'How must we think?'. The FIU was considered as
a response to this latter question. 170 photo Dietmar
Walberg, courtesy Pressebüro der Documenta GmbH Klaus
Becker; 171 photos Richard Demarco, courtesy Demarco
Digital Archive

172 & 173: 16 Beaver Group
The final meeting of the Continental Drift Seminar,
organised by Brian Holmes in collaboration with the
16 Beaver Group – an artist community running a social

and collaborative space at 16 Beaver Street in downtown Manhattan. Photos 16 Beaver Group

174 top: Mountain School of Arts
Dan Graham speaks with a group of students at the Mountain School of Arts, an artist-run school that convened in a back room above the Mountain Bar in Chinatown, Los Angeles. The bar has since closed, but the programme continues. Courtesy Piero Golia

174 bottom: The School of Walls and Space
The communal studio at the School of Walls and Space, run by Nils Norman at the Royal Danish Academy of Fine Arts, Copenhagen. Photo Nils Norman

175: The Public School
A flowchart illustrating the development of a course with the Public School, from proposal to final documentation. Described as a 'school with no curriculum', The Public School has organised courses based on this principle since 2007. Image Common Room and Geoff Han

176: The Protocols for a Listening Session
The Protocols for a Listening Session describe Ultra-red's use of group discussion, recorded sound, and writing as techniques for the collective investigation of political issues in the School of Echoes. Courtesy Ultra-red, 2011

177: New School Walkout
Leaflets handed out in May 2010 by an anonymous New School and NYU students for a national day of action against austerity measures affecting education. The New School had been occupied in 2008 and 2009, and in both instances students demanded the resignation of then-president Bob Kerrey. The student centre at New York University was also occupied in 2009.

178 & 179: Vienna 2009
In 2009, students at the Vienna Academy of Arts (pictured) and other colleges and universities across the city were involved in a series of mass protests. The students demanded curriculum reform, free access, democratic process, the realisation of the Disability Discrimination Act, and an end to precarious employment and gender discrimination across the universities.

180 & 181: Sussex Occupation
Sussex University experienced widespread protest and occupations in the summer of 2012 due to the unexpected and unilateral decision by the University to privatise most campus services. The move reflects similar efforts at public UK universities to 'externalise' the costs and liabilities of everything from building maintenance to student advisory.

182 & 183: Book Bloc Italy
The Book Bloc has emerged as an international symbol of self-defence against police brutality in the struggle against the neoliberalisation of education. This photo shows a book bloc in Rome, next to Università La Sapienza in 2010. Photo BerlinRomExpress

184: Cooper Union
The Cooper Union's Foundation Building was first occupied in December 2012 and again in May 2013 in response to the widely criticised decision by the administration to end its 150-year tradition of offering free tuition. Photo Julie Harris

185: Bank of Ideas
The Bank of Ideas was a platform for self-organised education, initiated in London in 2011 by a number of organisations related to Occupy UK. Squatting a building owned by UBS Bank, the Bank of Ideas offered teach-ins,

seminars and a space for organising further Occupy actions.
Photo Andy Roberts

186: London 2010
On 10 November 2010, mass protests took place in London
against the increases in tuition fees that were expected to
result from the cuts in higher education implemented by
the coalition government of the Conservative Party and the
Liberal Democrats. Officially called 'Fund Our Future: Stop
Education Cuts', the protest was attended by an estimated
50,000 people. Photo Geoff Dexter

187: Occupation of the Tory Headquarters
During the first protests in London 2010, a group of
protesters left the main route of the march and occupied
the lobby of the headquarters of the Conservative Party
at 30 Millbank. The occupation escalated in a violent clash
with the police, and the smashing of the windows of the
headquarters. Photo Matthew Williamson

188 & 189: Occupy Library
The Occupy Wall Street People's Library at Zuccotti Park,
which existed during the occupation of 2011, described
itself as 'the collective, public, open library of the Occupy
Wall Street leaderless resistance movement.' New York City
Police officers destroyed 5,000 books in the library when
they raided Zucotti Park in November 2011.
Photo David Shankbone

190 & 191: Middlesex 2010
Various protests took place at Middlesex University following
the university management's decision in April 2010 to close
the philosophy department. Despite its acclaimed staff,
steady recruitment of students, high academic ranking and
international acclaim, Middlesex University closed the
department on the grounds that it was not financially viable.

192: Slade Occupation
Occupations at University College London began in the winter of 2011 to protest against the coalition government plans to cut university budgets and allow tuition fees up to £9,000 per year. Under the banner of 'Art Against Cuts', The Slade School of Art at UCL was occupied by students in January 2011. Photo Matthew B Coleman

Cover images
Jacket: Berkeley Book Tents
After being evicted from the UC Berkeley campus, student Occupy protestors in the autumn of 2011 left books where their tents once stood. In 2009, Students across the University of California system protested against an unprecedented 32 per cent rise in tuition fees. Photo Arturo Snuze

Back: Antiuniversity of London Registration Form
Courtesy PETT Archives

I·L·E·A · SAINT · MARTIN'S · SCHOOL · OF · ART
109 CHARING · CROSS · ROAD · LONDON · W · C · 2 · TELEPHONE · 01-437 0058/9

JOHN BURKE

SCULPTURE DEPARTMENT	September 28th
DIP A.D.I.	1970

Welcome to St. Martin's Sculpture Department.

Your course of work here will begin in a few moments.
Initially this course of work will be carefully structured by
the staff. It will take place in the area beyond the door
marked '1st year project area'. This enclosed area is
allocated by the Sculpture Department for your exclusive use.

The situation which we are about to enter has been designed
in considerable detail. This situation we call a project. It
is anticipated that we will all find this project extremely
demanding.

You are required to wear the enclosed name badge during the
working hours. You may obtain tools from the Sculpture
Department's Material Store on the 8th floor of the main
building. There are certain items which you will not be
permitted to use, including writing and drawing instruments.

Additional instructions have been displayed inside the project
area.

 1st year staff
 P. Atkins
 G. Evans
 P. Harvey
 G. Jones

165

ANTIUNIVERSITY of LONDON

MUSIC ART POETRY
BLACK POWER MADNESS
REVOLUTION

JOSEPH BERKE
ROBIN BLACKBURN
MALCOLM CALDWELL
CORNELIUS CARDEW
KEN COATES
DAVID COOPER
ED DORN

STUART HALL
RICHARD HAMILTON
JIM HAYNES
CALVIN HERNTON
FRANCIS HUXLEY
NICHOLAS KRASSÓ
ALLEN KREBS
MICHAEL KUSTOW

R. D. LAING
DAVID MERCER
MILES
JULIET MITCHELL
STUART MONTGOMERY
RUSSELL STETLER
ALEXANDER TROCCHI

AND OTHERS

OPENS 12th FEBRUARY 1968

49 RIVINGTON STREET
SHOREDITCH E.C.2
01-739 6952

MEMBERSHIP £8

NO FORMAL REQUIREMENTS

Write for Catalogue

* John Chamberlain American sculptor & film-maker doesn't know hasn't any couldn't, but maybe might have been credited with some chaos transferred. I think.
Tuesday June 18th at 8.30 and thence fortnightly

WEEKEND SEMINAR
29th -30th June
ARTS AND FAKES OF LIVING
A course of study led by William MacLellan

Faking living has now reached the new high counterfeiting means of relationships - cooking the books of response
This weekend course sets out to discover why we mess up our lives /A weekend for those prepared for two whole days of 24 hours in which to

The Stuart Montgomery/Asa Benveniste course on Eroticism- is the weekend of 13th/14th July

*Malcolm Caldwell, because of a matter which is <u>sub judice</u> will be unable to continue to teach this term, but hopes to resume as soon as possible

*Carolee Schneemann A HAPPENING (previous works include the happenings "Meat Joy", "Snows", and "Water Light/Water Needle" Also referred to as action theatre, kinetic theatre or event theatre WILL MEET with people with a view to creating something that could be performed at the Antiuniversity itself INTENSIVE numbber of meetings for 1 month, 24th June to July 24th

BRIEF NOTES: Portable typewriter missing from Office. Anyone know its whereabouts? Needed another bulletin board. Any offers? Speakers on the Antiuniversity needed to go to far towns to take part in conferences etc., for expenses or even for a fee. Any volunteers, please?

THE ANTIUNIVERSITY has been run up to now with as little organisation as possible. Some people feel we still have too much organisation; some that we have too little. It is good that such matters are being debated. An exchange of views is desirable. Short views on any matter relating to the functioning of the Antiuniversity could well be incorporated in future issues of this Newsletter. Longer views and Statements on What the Anti university is or should be or could be are invited and could be incorporated in the second issue of the magazine due out soon.

Newsletters are planned to appear at fairly frequent intervals, about every fortnight. Items for the next newsletter should therefore be sent to us fairly soon after the current one is received

Newsletter
Antiuniversity

Antiuniversity of London

It has been necessary to give up the premises at Rivington Street because of lack of funds, and until we have more money, courses and seminars are being held in members' homes and other places. Information about all meetings can be had by writing to 1, Sherwood Street, W, or by telephoning Bill Mason at 01-289-0998.

The registration fee is now £5 a year starting in September and will admit members to all courses, but unless cards are shown a visitor's fee of 5/- will be charged. Notification of all public lectures sponsored by the Antiuniversity will be first sent to members who will be able to attend at half price. We hope to arrange that membership cards may be used to obtain the usual student discounts. Any member who has already paid for the summer session will be sent a year's membership.

A room will be rented in a pub for a general meeting and get together on the second Friday in September when future courses could be discussed. The time and place will be known by the last week in August - ring Bill Mason after that for details.

Courses now meeting are:

- Action Research Project on Racialism
- Roy Battersby / Leon Redler / Roger Gottlieb
 Time and Timelessness
- Bob Cobbing / Anna Lockwood
 Composing with Sound
- David Cooper's Seminar
- Roberta Elzey Berke
 On Finnegans Wake
- Guerilla Poetry Workshop

(...over)

Is your teacher really teaching? *What about an anti-inter-university university?* *Can students teach teachers?*

YOU AND THE ANTI-U

Do we need bigger premises?

These past four months have proved than an anti-university can survive,---it can even grow. The question is in what directions?

Rent St. Pancras Station or the Heath?

We feel it is necessary to depass our birth and commit ourselves to a new community development. Any organization which wishes to be meaningful, not only to the world outside but more importantly, to its self, must re-examine itself at each step. To do otherwise is a symptom of death.

At this juncture we find ourselves feeling strongly the possibilities for new growth:---

Whos going to do the dirty work?

> an increase in direct contact, founded on something more than the present teacher/student role relationships;
>
> an increase in the participation of all members in decision-making and planning;
>
> an increase in communication and co-operation between classes, with an eye towards a more critical appraisal of the various courses.

Where is our money going?

Perhaps these developments cannot come about without real qualitative changes: an end to the distinctions between 'student', 'teacher', 'administration', and all that implies socially and financially.

Whither the Anti-U

These are some suggestions as to how the Anti-university can develop. No doubt there are many more. For this reason,

A GENERAL MEETING

What do we know of ourselves?

will be held on

SATURDAY MAY 11

AT 2:30

Course listings and goals without teachers

at the Anti-university

and the hall of Shoreditch Parish Church

ALL THOSE INTERESTED IN THE FUTURE OF THE

ANTI-UNIVERSITY ARE INVITED TO ATTEND.

*Pay the students
Charge the teachers!*

Is democracy possible?

Courses in Yoga and Macrame... *More turnover to the broad pud!*

Der erweiterte Kunstbegriff
als wesensgemäßer Kapitalbegriff

(Joseph Beuys)

FIU - Baumkoordination
7000 Eichen

" Deutschland? - aber wo liegt es?
Ich weiß das Land nicht zu finden "

(J.W. Goethe)

FREE INTERNATIONAL UNIVERSITY

KUNST=KAPITAL

documenta 7 Kassel
19. Juni — 28. September 82

Es wirken mit: Bernhard Achterberg · Herbert Ammon · Rudi Bahro · Joseph Beuys · Holms Boeck · Alke Brachtlochinski · Daniel Cohn-Bendit · FIU Düsseldorf · FIU Emsdetten · FIU Essen · FIU Hamburg · FIU Kassel · Josep Fiochtmann · Forschungsprojekt Soziale Innovation · Freie Schule Bochum e.V. · Freie Schule Frankfurt · Jörn Freund · Friederike Frey · Fredrichshof · Horst von Gyzicki · Giochbeere Schule · Helga Götze · Gerhard Gruß · Diskussionszentrum/Gewaltfreie Aktion · Ulrike Greszarth · Dieter Hasselnpflug · Jürgen Heckmann · Marlene Heidel · Otto Herz · Milan Horacek · Eva Hutz · Michael Kolbrig · Hakkan Kennedy · Margit Kennedy · Rimo und Kunst Sozialdienst · D. H.-user Völmer · Rüdiger Lutz · Robert F. Mayer · Jörg Mittler · Bri Mellmann · Wencke Mühleisen · Nützwerk Selbsthilfe Berlin · Ottermald Schule · Forstar Panouskapolos · Michael Pfister · Projekthalle Graz · Rufan Respell · D. E. Sailer · Schule für Gestaltung Friedrichsdorf · Karl Heinz Schalling · Rolf Scheremtlar · Johannes Stettheim · Sommerhochschule der HWP Hamburg · Ulrich Sonnemann · Bernd Storn · Lioi Storn · Johannes Stuttgen · Rhea Thönges · Peta Völmer · Helga Weber-Zucht · Claudia Weissensteiner · Lebenstein Myers · Wilhelmshöhe Houston/Texas

FIU-Koordinationsbüro
7000 Eichen / Orangerie
An der Karlsaue 22A
3500 Kassel
Tel.: 0561 / 14957

171

173

> / PROTOCOLS FOR A LISTENING SESSION / have been composed by Ultra-red for organizing collective listening to pre-recorded sounds. The protocols seek to put the recording and its listeners into process by privileging the ear that hears over the sound recording itself. [Los Angeles, 60 min, 25. 06. 2011]

0

1. *Introductions* — To begin; invite every person in the group to introduce herself or himself by name, any organizational affiliation and the kind of work that they do. Participants can also say what they want to hear the group talk about.

2. *Listen to the sound objects* — Play a series of sound recording one to two minutes in length, one at a time over the sound-system without introduction.

3. *"What did you hear?"* — After playing each sound recording, ask the group, "What did you hear?" Write exactly what is said, even duplications onto flip-chart paper.

4. *Tell the story* — Ask the person who made the recording to tell the story behind the sound; not to validate or invalidate the responses but as another object for reflection.

5. *"What did you hear?"* — After the story has been told, ask the group, "What did you hear?" Write exactly what is said, even duplications onto flip-chart paper.

6. *Repeat steps #2 to #5 for each sound recording.*

7. *Analyze what is heard* — Compare the responses to all the recordings and stories. Note the responses that are convergent and, especially, those that are divergent.

8. *Discuss the theme(s)* — Discuss the most urgent issues to emerge from the responses to the sound recordings. The tendency in such discussions can be to arrive at an agreement on the important themes. The process of agreement often attempts to resolve differences in experience or knowledge. Give attention to those divergences not as differences to be conquered or argued but as problems to be investigated.

9. *Write the theme(s)* — Compose the theme in the form of a question or a proposition that will be researched in actual lived experiences, either one's own or within those communities where the theme organizes the experience of everyday life.

STUDENTS:
REFUSE YOUR ROLES

STRIKE today:
 against education as
 market conditioning
 against the student
 as commodity
 for the reclamation
 of all social life

THE CULT OF WORK
THE STATE
CAPITAL
THE PRIMACY OF ROLES
THE HIERARCHICAL ORDER

each wing of boredom
of routine
of the policed life
must be turned to beautiful rubble

RENEW YOUR DESIRES
TO LIVE IS AN ECSTATIC CRIME

 FOR EVERY BUREAUCRAT, COP,
 CAPITALIST, USURPER,
 & LEADER

 THE TRASH HEAP

178

180

181

184

185

186

188

189

EDUCATION IS NOT THE FILLING of a pail BUT the LIGHTING of a FIRE

REGISTRATION FORM

Name:

Address:

Telephone:

Courses (insert name of faculty member):

1.

2.

3.

4.

5.

6.

Where required for registration, please supply additional information on a separate sheet.

Make cheques or postal orders payable to the Antiuniversity of London and post with this form to **49 Rivington Street, London EC2**.